IMAGES
of America

CLEVELAND'S LITTLE ITALY

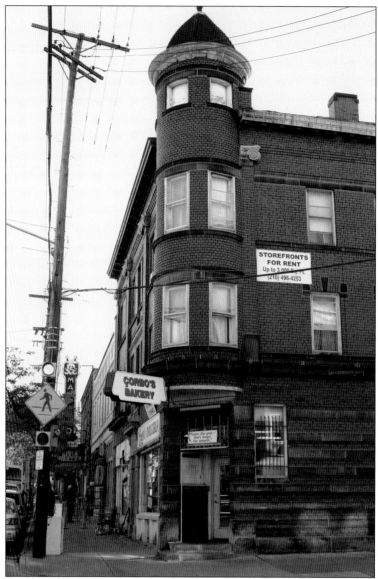

LITTLE ITALY STREET SCENE. Little Italy, once mostly farmland, became home to a majority of Cleveland's Italian immigrants in the late 19th and early 20th centuries. Today the mix of residents in the neighborhood is about 30 percent those of Italian descent with the rest made up of young professionals, many of whom work at University Hospitals of Cleveland and Case Western Reserve University just blocks away, and those looking for a unique, historic, and vibrant place to live. (Terry M. Goodman.)

On the cover: **ALTA HOUSE SUMMER CAMP.** Established in 1895 as a day nursery for the residents of Little Italy, Alta House grew into a community center and source of a wide range of social services. Funded by financier John D. Rockefeller and named after his daughter, Alta House particularly catered to young residents, even establishing a summer camp program (pictured on the cover). Alta House continues to serve Little Italy residents today. (Little Italy Heritage Museum.)

IMAGES of America
CLEVELAND'S LITTLE ITALY

Sandy Mitchell

ARCADIA
PUBLISHING

Copyright © 2008 by Sandy Mitchell
ISBN 978-0-7385-5213-2

Published by Arcadia Publishing
Charleston SC, Chicago IL, Portsmouth NH, San Francisco CA

Printed in the United States of America

Library of Congress Catalog Card Number: 2008920505

For all general information contact Arcadia Publishing at:
Telephone 843-853-2070
Fax 843-853-0044
E-mail sales@arcadiapublishing.com
For customer service and orders:
Toll-Free 1-888-313-2665

Visit us on the Internet at www.arcadiapublishing.com

To the people of Little Italy, past and present

Contents

Acknowledgments		6
Introduction		7
1.	Beginnings	9
2.	Expansion	21
3.	Change and Evolution	43
4.	The Institutions	53
5.	The People	81
6.	The Food and the Restaurants	107
7.	Little Italy Today	119
Bibliography		127

Acknowledgments

So many individuals helped to make this book a reality. I would like to thank Lynn Duchez-Bycko, the patient and extremely knowledgeable keeper of the over 500,000 photographs that make up the Cleveland Press Collection at Cleveland State University Library. Also helpful were the staffs at the Little Italy Heritage Museum and the Cleveland Public Library Special Collections Department. This project made me realize what a treasure of original historical documents and images are readily accessible to the public right here in northeast Ohio. I encourage readers to take advantage of these mostly free resources.

Thank you also to Melissa Basilone, my editor at Arcadia Publishing, for her confidence in me, her patience, and her guidance, which combined to make this book so easy to produce.

And finally, I offer a special thanks to Nicole Bryson, my assistant, for her hours scanning images and proofreading and to Terry M. Goodman of Platinum Photography for her excellent modern photographs of Little Italy. Your help was invaluable.

INTRODUCTION

Like its predecessor Big Italy, centered around Cleveland's Woodland Avenue and East Twenty-second Street, the city's Little Italy neighborhood grew up as a community of Italian immigrants. Unlike the tradesmen and laborers that peopled Big Italy, the men and women who developed Little Italy were mostly artisans—tailors, woodworkers, and stonecutters. It is no coincidence that Little Italy is located adjacent to Cleveland's elegant parklike Lake View Cemetery, opened in 1869. Many of the cemetery's monuments and mausoleums were crafted by Italian immigrants living in Little Italy.

Little Italy became a thriving, vibrant community due in large part to an unlikely pied piper—Joseph Carabelli. Different from most of the people whom he encouraged to settle in the area, Carabelli was from northern Italy, was a Protestant, and had spent 10 years working in New York City before moving westward to Cleveland. His Lake View Granite and Monumental Works provided employment for more than a few new arrivals.

In addition, Carabelli's friendship with Clevelander John D. Rockefeller provided the neighborhood with funds for services and programs that would keep most of Cleveland's Italian new arrivals away from public assistance. The most notable of these projects was the creation of Alta House, named for Rockefeller's daughter. The institution, which combines community services with social activities, thrives to this day.

As with most Italian American neighborhoods, the Catholic Church played an important role in the neighborhood's development. In addition to religious support, the Holy Rosary parish was a source of education, social services, and recreational activities. The church-sponsored Feast of the Assumption, held each August since the early 1900s, has always been the highlight of the Little Italy calendar and today draws over 100,000 visitors annually.

Any neighborhood is defined by its residents, and Little Italy is no different. Past residents have included Hector Boiardi, better known to the world as Chef Boy-ar-dee, who had a restaurant in the neighborhood in the 1930s and 1940s; Anthony J. Celebrezze, former Cleveland mayor, cabinet member under John F. Kennedy, and federal judge; and Angelo Vitantonio, who invented the first pasta maker in 1906.

As Americans moved to the suburbs in the 1950s and 1960s, Cleveland's neighborhoods were particularly hard hit. Little Italy lost over half its residents during this time to new houses in Lyndhurst, Mayfield Heights, and Parma. The second- and third-generation Italian Americans who fled to these suburbs, however, continued to support the businesses in the old neighborhood, and many have survived, including Guarino's, Cleveland's oldest Italian restaurant.

In the 1980s, Little Italy redesigned itself as an arts district, remodeling the old elementary school to house affordable artist studios and galleries as a way to encourage Clevelanders

to relocate in the many vacant buildings. Today Little Italy draws visitors from all over the city and beyond with its mixture of Old World charm and avant-garde art and design. It is a winning mix.

Cleveland's Little Italy tells the story of one ethnic Cleveland neighborhood's rise, slump, and reemergence as a lively community and a tourist mecca. Using historic photographs, amassed from local archives and private collections, this book illustrates the best, the worst, and the all-too-human side of an always interesting slice of Cleveland.

One

BEGINNINGS

Cleveland, in the mid-19th century, had expanded from the handful of early settlers who purchased plots of land for $1 as part of the Connecticut Western Reserve, an extension of that East Coast state into what was, in the 18th century, undeveloped wilderness. Ohio had become a state in 1804, and following the Civil War, Cleveland grew almost overnight, from a quiet outpost to a vital industrial town.

Cleveland's growth, and the jobs it created, was attractive to many of the thousands of immigrants arriving in the United States from Europe, including those from Italy. The early arrivals settled in Big Italy, an enclave located just east of downtown along Woodland Avenue. The first Italians were mostly laborers and grocers, who set up stores in the neighborhood.

By the 1880s, a few intrepid Italian immigrants had migrated farther east to the area south of Euclid Avenue, bounded by Lake View Cemetery. The most notable of this group was Joseph Carabelli, a stonecutter who created a stoneworks company that created many of the elaborate monuments that grace Lake View. He enticed other Italian artisans to join the community, and Little Italy began to take its shape.

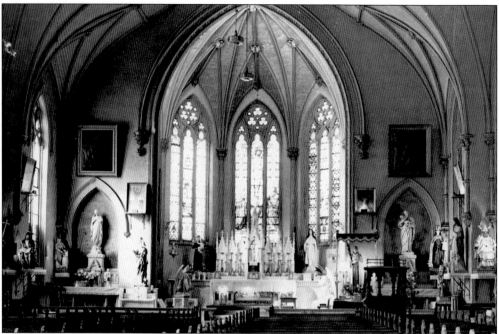

INTERIOR OF ST. ANTHONY'S CHURCH. The local church was always an important part to any Italian neighborhood. St. Anthony's parish, founded in 1886, was the first church in Cleveland to serve the growing Italian population. The parish built a redbrick Romanesque church at East Thirteenth Street and Carnegie Avenue in 1904, which remained until 1961, when it was demolished to make way for the innerbelt highway. (Cleveland State University/Cleveland Press Collection.)

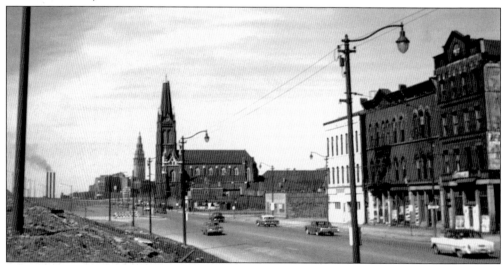

BIG ITALY. The neighborhood bounded by Orange, Woodland, and Ontario Avenues and East Fortieth Street, dubbed Big Italy, was Cleveland's first Italian community. Immigrants began arriving there in the 1860s and found jobs in the area's many groceries and food markets. The neighborhood's Italian population declined, from a high of 4,429 in 1910 to just 180 in 1960, as residents moved east to the Little Italy, Kinsman Road, and Collinwood neighborhoods. (Cleveland State University/Cleveland Press Collection.)

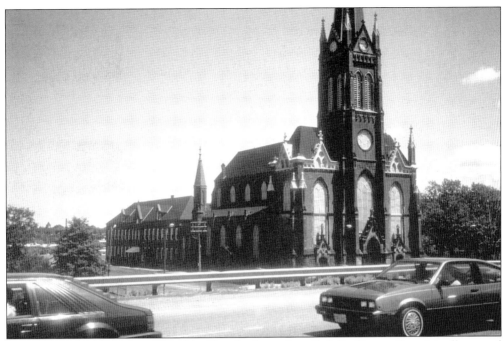

ST. JOSEPH'S CHURCH. St. Joseph's Church, formerly called St. Bernard's, originally served the primarily German residents of the Woodland Avenue neighborhood in the early 19th century. The Franciscans took over the church in 1868 and adapted it to serve the new residents of the area—Italians, Poles, Slovaks, and Czechs. (Cleveland State University/Cleveland Press Collection.)

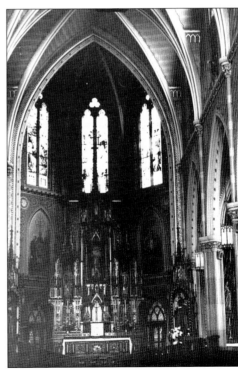

INTERIOR OF ST. JOSEPH'S CHURCH. St. Joseph's, located at East Twenty-third Street and Woodland Avenue, was noted for its intricate wood carvings and large leaded glass windows. The church, with a dwindling membership, was closed and deconsecrated in 1986. While its future was being discussed, the church burned nearly to the ground and was demolished in 1993. (Cleveland State University/Cleveland Press Collection.)

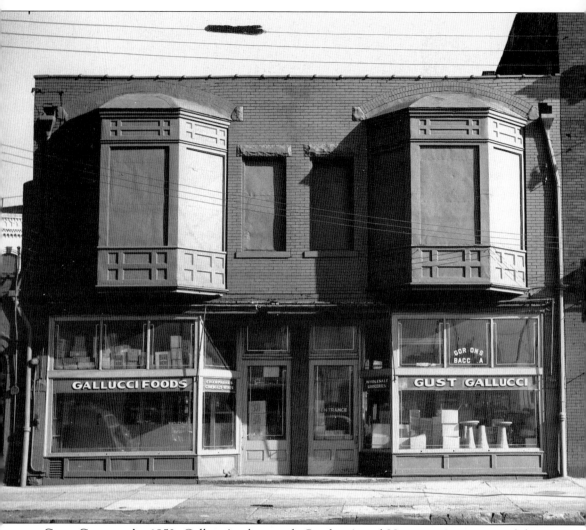

GUST GALLUCCI'S, 1953. Gallucci's, along with Catalano's and Vitantonio's, was one of the early Italian groceries to serve the Big Italy community. Gallucci's, now on Euclid Avenue in Cleveland's Midtown neighborhood, is one of several Cleveland businesses to survive from that era. (Cleveland State University/Cleveland Press Collection.)

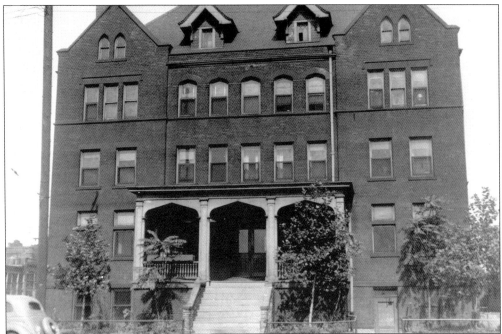

HIRAM HOUSE. Hiram House, located along Orange Avenue near Big Italy, was an early settlement house that assisted thousands of new Italian immigrants, as well as those of other nationalities, to learn English, find a job, and get acclimated to life in Cleveland. The facility remained open until the early 1940s. (Cleveland State University/Cleveland Press Collection.)

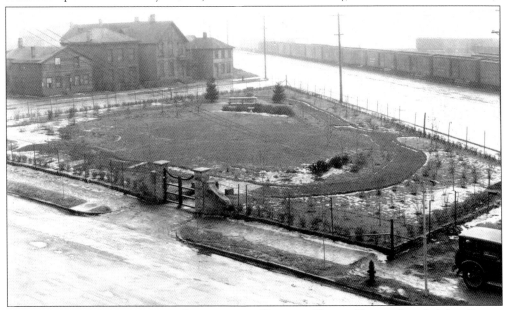

ONE OF CLEVELAND'S EARLY SETTLEMENT HOUSES. Hiram House, founded by George Bellamy, originally served a primarily Jewish community, but as Italians moved into the area, they eventually found a welcome at the center. In addition to language and vocational training, Hiram House acted as a social center, even hosting an Italian band. (Cleveland State University/Cleveland Press Collection.)

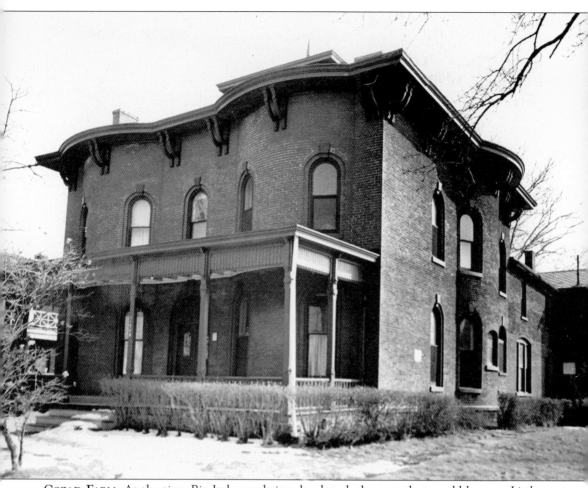

COZAD FARM. At the time Big Italy was being developed, the area that would become Little Italy was farmland, most of which was owned by Samuel Cozad. His property stretched all the way to what is now University Circle. In fact, Little Italy's Murray Hill Road was originally named Cozad Street. The Cozad family home (above) still stands and has been added to the National Register of Historic Places. Samuel Cozad was an early Western Reserve settler, part of the many East Coast families that took advantage of the inexpensive land being offered in northeast Ohio in the early 19th century. The Cozad family arrived in the area in 1806 to live on and farm land they purchased for $1. Cozad married Mary Condit, and they had one son, Newell. Samuel Cozad is buried at Lake View Cemetery. (Cleveland State University/Cleveland Press Collection.)

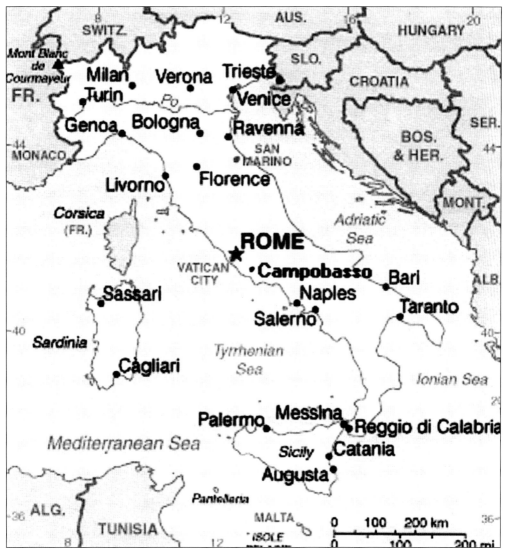

MAP OF ITALY. Most of the early Italian residents of Little Italy came from Sicily and southern Italy. The largest group of immigrants came from the towns of Ripamolisano, Madrice, and San Giovanni in Galdo, which are in the province of Campobasso, in the Abruzzi region of Italy. Later arrivals came to join friends and family already in the neighborhood. (Central Intelligence Agency *World Factbook*.)

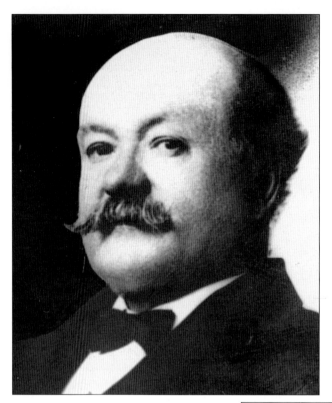

JOSEPH CARABELLI. Joseph Carabelli was not Cleveland's first Italian immigrant, but he certainly made the biggest impact on the burgeoning Italian community. A stonecutter in New York City for 10 years before arriving in Cleveland, Carabelli was a northern Italian and a Protestant—unlike most of the other Italian immigrants. He donated money and land for many of the neighborhood's landmarks. (Little Italy Heritage Museum.)

LAKE VIEW GRANITE AND MONUMENTAL WORKS. Carabelli's Lake View Granite and Monumental Works employed stonecutters and artisans from Italy and Germany. The business thrived for over 50 years, headed by Carabelli's two sons after the founder's death in 1911. (Little Italy Heritage Museum.)

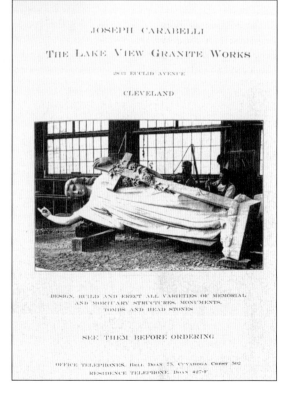

JOHNS-CARABELLI COMPANY AND HASEROT MONUMENT. Carabelli founded his stonecutting business just outside Little Italy, on Euclid Avenue, across from Lake View Cemetery. The company created many of the elaborate stone monuments and mausoleums for the cemetery as well as statues and monuments for town squares around northeast Ohio. Surviving examples of the company's work include the Haserot Monument (below) at Lake View Cemetery, which was carved in 1880 by Carabelli, and the Civil War memorials in Elyria and Willoughby. The Carabelli name and tradition for excellence live on with the Johns-Carabelli Company in the Cleveland suburb of South Euclid. (Author's collection.)

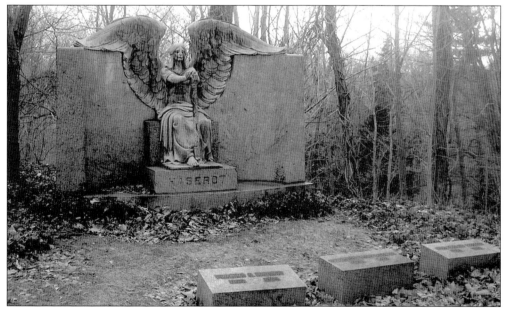

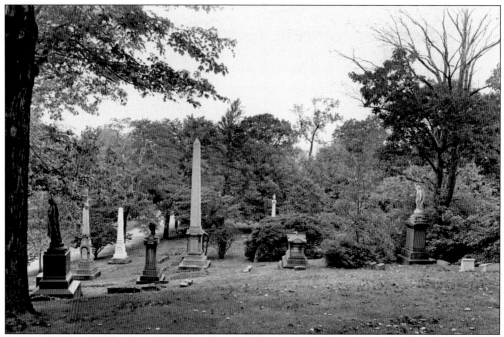

LAKE VIEW CEMETERY. Lake View Cemetery holds the remains of many Little Italy residents—both the illustrious and the humble. In addition to being noted for its elaborate stone monuments, Lake View is known for its policy of accepting anyone for burial, no matter their wealth, race, or ethnic background. (Cleveland State University/Cleveland Memory Project.)

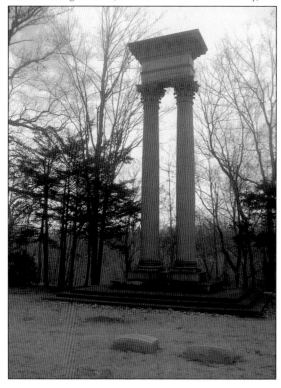

BRUSH MONUMENT AT LAKE VIEW CEMETERY. Lake View Cemetery marks the eastern boundary of Little Italy. Many of the cemetery's stone monuments and mausoleums, for prominent Clevelanders such as John D. Rockefeller and Jeptha Wade, were created by Little Italy residents. Many examples, such as the Brush Monument (at left), may still be viewed at the parklike cemetery. (Author's collection.)

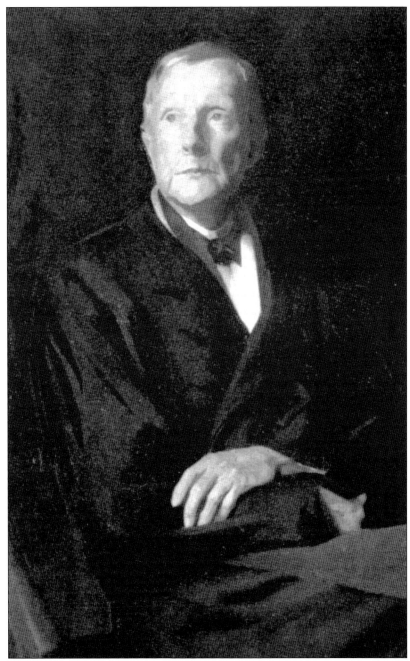

JOHN D. ROCKEFELLER. Joseph Carabelli became a close friend of then Clevelander John D. Rockefeller (above), founder of the Standard Oil Company. He persuaded the wealthy Rockefeller in 1895 to donate money for a neighborhood kindergarten and nursery. That facility grew to become Alta House, named for Rockefeller's daughter, Alta Rockefeller Prentice. Rockefeller continued his interest in the neighborhood, adding a library and gymnasium to Alta House in 1910. Although he moved his business to New York City in the early 20th century, he continued to maintain strong ties to Cleveland. Rockefeller is buried near Little Italy, in Lake View Cemetery. (Cleveland State University/Cleveland Press Collection.)

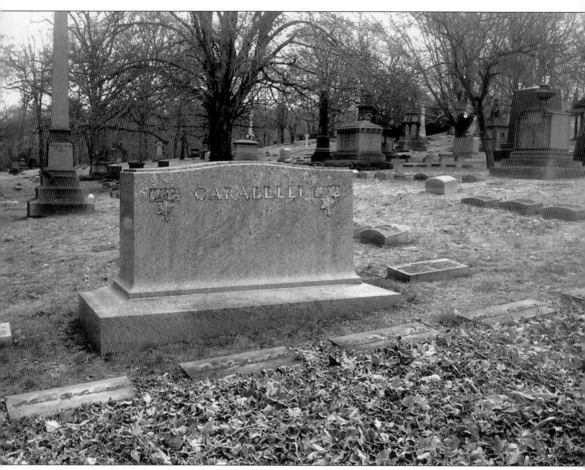

CARABELLI MONUMENT AT LAKE VIEW CEMETERY. Joseph Carabelli was elected to the Ohio House of Representatives in 1908, the first Italian American to hold office in the state. He kept his family and his business in Little Italy until his death in 1911. Carabelli, along with his wife and two daughters, is buried at Cleveland's Lake View Cemetery, honored by a large stone monument created by his company, the Lake View Granite and Monumental Works. (Author's collection.)

Two

EXPANSION

The continuation of the Cleveland Electric Railway in the early 20th century out to Mayfield Road made it easier and more attractive for Italian immigrants to migrate east to Little Italy. Friends and relatives from abroad joined residents already established in the neighborhood, and the area grew from a tiny enclave to a self-contained and self-sufficient community in less than a decade. New arrivals found work as stonecutters, garment workers, and food handlers and waiters in Cleveland's growing number of Italian eateries.

The United States' entry into World War I in 1917 gave these new Clevelanders a chance to show their support of their adopted nation and hundreds enlisted. However, Benito Mussolini's rise to power in Italy during the 1920s generated conflicting opinions and feelings in Cleveland's Italian community. Many felt that the dictator's capital improvements and new jobs outweighed his disregard for human rights. Those sentiments changed abruptly in 1940 when Italy declared war on France and England. Mussolini found very little support in Cleveland after that time.

The late 1920s and early 1930s brought new challenges to the citizens of Little Italy. The Great Depression hit this area especially hard, and over half the neighborhood's families were out of work. The Works Progress Administration (WPA), later called the Work Projects Administration, helped somewhat, but participants were only given two weeks' work each month.

Prohibition confounded most of the Italian community. Most residents had been raised in a culture where wine accompanied every meal, church service, and celebration. All of a sudden, this was illegal. The Prohibition era also gave rise to a small criminal element in the area, which saw a profit to be made in bootleg liquor.

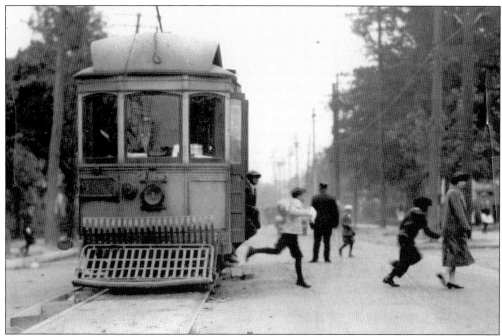

CLEVELAND ELECTRIC RAILWAY. The expansion of the Cleveland Electric Railway in 1901 out to Mayfield Road made it easy for Italian immigrants to move east to Little Italy and still work in and around downtown Cleveland. Fares were just 3¢, with a penny for transfers. (Cleveland State University/Cleveland Press Collection.)

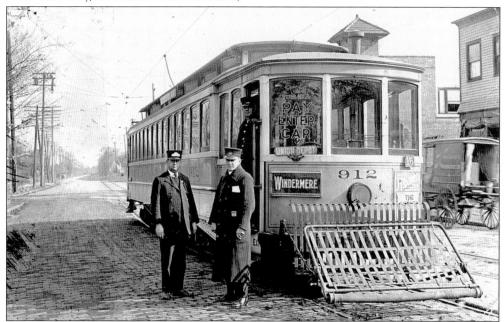

RAILWAY CAR. In 1901, the Cleveland Electric Railway Company system included 135 miles of track, 426 motorcars, and 83 trailers. The system merged with the larger Cleveland City Railway Company in 1903, which more than doubled the number of cars in use. (Cleveland State University/Cleveland Memory Project.)

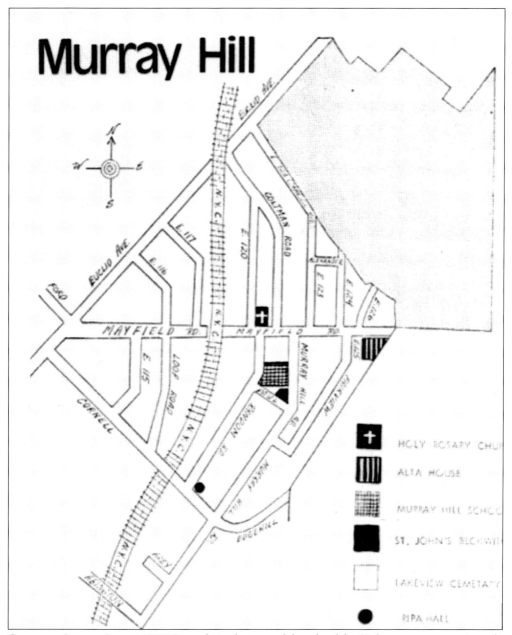

CHART OF LITTLE ITALY, 1910. By early in the second decade of the 20th century, approximately 96 percent of the population of Little Italy was Italian-born and another 2 percent were born of Italian parents. Many of the residents of this compact neighborhood were skilled in lacework, the embroidery trades, and garment making. (Cleveland State University/Cleveland Press Collection.)

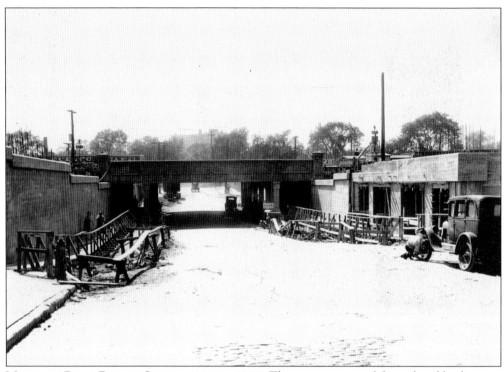

MAYFIELD ROAD BRIDGE CONSTRUCTION, 1929. The construction of the railroad bridge over Mayfield Road in 1929 and the addition of the nearby Cleveland Union Terminal brought an influx of jobs to the Little Italy area. In order for the road to pass under the new bridge, the grade on Mayfield had to be lowered (below). The Mayfield Road Bridge still marks the northern boundary of Little Italy. (Cleveland State University/Cleveland Memory Project.)

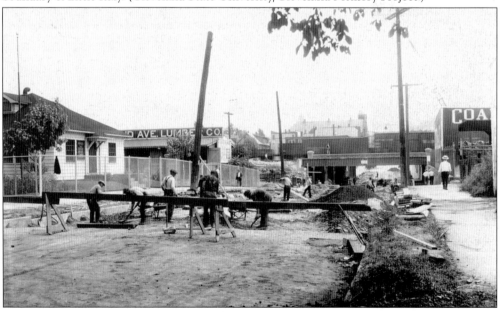

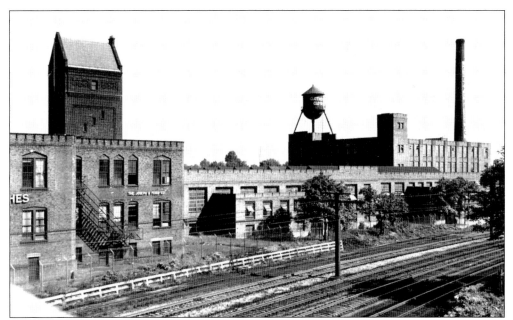

JOSEPH AND FEISS COMPANY. A large number of the Italians who settled in Little Italy during the early 20th century were skilled tailors, seamstresses, and lace-makers. Many found work in the textile mills and factories around Cleveland, including the Joseph and Feiss Company on St. Clair Avenue and later on Cleveland's near west side. (Cleveland State University/Cleveland Press Collection.)

INSIDE THE JOSEPH AND FEISS FACTORY. Joseph and Feiss, originally a clothing wholesale company from Meadville, Pennsylvania, began manufacturing its own line of clothes in 1897. Its affordable $15 blue serge suit became known as the "Model T" of the clothing industry in 1925. The company was acquired by the Phillips–Van Heusen Corporation in 1966 and later by Hugo Boss. A small operation remains in the Greater Cleveland area. (Cleveland State University/Cleveland Press Collection.)

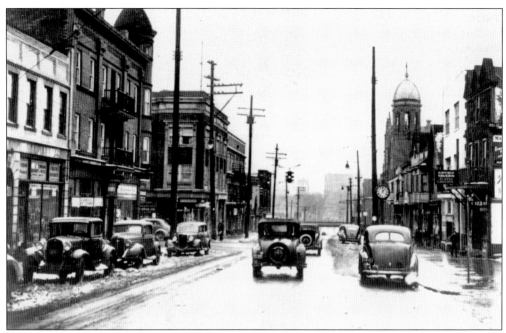

MAYFIELD ROAD, LITTLE ITALY, 1913. By 1913, Little Italy had everything a neighborhood could desire. The bustling business district on Mayfield Road boasted seven groceries, a dozen bars, a theater, several restaurants, and a drugstore. Residents rarely ventured out of the neighborhood, except to go to work. (Cleveland State University/Cleveland Memory Project.)

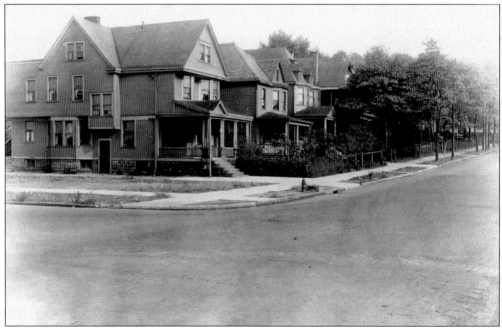

RANDOM AND CORNELL ROADS, 1920s. Little Italy's new residents brought with them the traditions of the old country. Many of the large frame houses in the neighborhood were home to more than one family, usually an extended family with cousins and in-laws, headed by the matriarch, the oldest female relative. (Cleveland State University/Cleveland Memory Project.)

ITALIAN COOKS IN CLEVELAND. The burgeoning Italian community was also known in local culinary circles. It was estimated that in the 1920s, approximately 70 percent of the cooks in Cleveland's restaurants and private homes were of Italian descent. Italian restaurants flourished in the city, from downtown's Euclid Avenue to Mayfield Road in Little Italy. (Cleveland State University/Cleveland Press Collection.)

RESTAURANT WORKERS IN CLEVELAND. Italians were not just represented in the kitchen. By the 1920s, a large number of Cleveland's waiters and dining room stewards were of Italian descent. Clevelanders enthusiastically espoused the tasty and affordable food of southern Italy. (Cleveland State University/Cleveland Press Collection.)

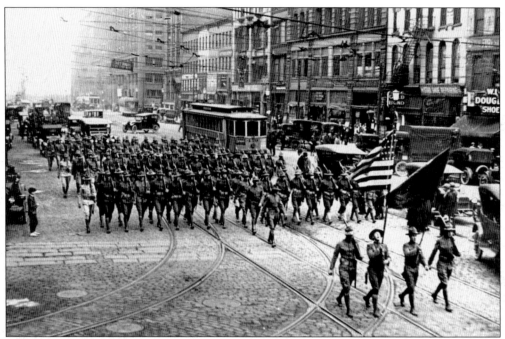

TROOPS MUSTERING FOR WAR, 1917. Cleveland's new Italian residents were very patriotic toward their new home, and when the United States entered World War I in 1917, many Little Italy residents were eager to enlist. (Cleveland State University/Cleveland Press Collection.)

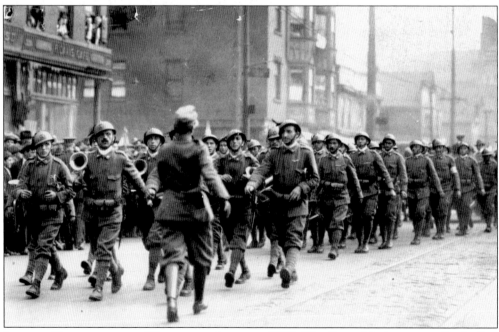

ITALIAN BERSAGHIERI ON WOODLAND AVENUE, 1918. The Bersaghieri were an elite Italian fighting corps that originated as a royal Italian army. In World War I, they sent over 200,000 soldiers to combat. After Armistice Day, in 1918, a regiment visited Cleveland, much to the delight of the Italian community. (Cleveland State University/Cleveland Press Collection.)

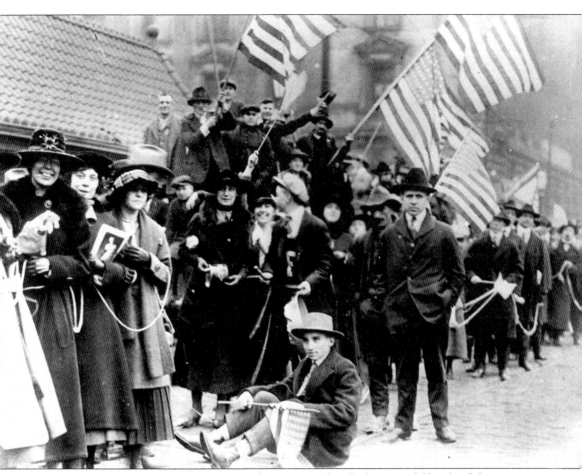

CELEBRATING ARMISTICE DAY, 1918. Italians rejoiced with the rest of Cleveland downtown in Public Square as the end of the Great War in Europe was announced on November 11, 1918. Although the United States had only been involved in the war for less than two years, Cleveland had seen over 1,000 casualties, including many Italian Americans. (Cleveland State University/Cleveland Press Collection.)

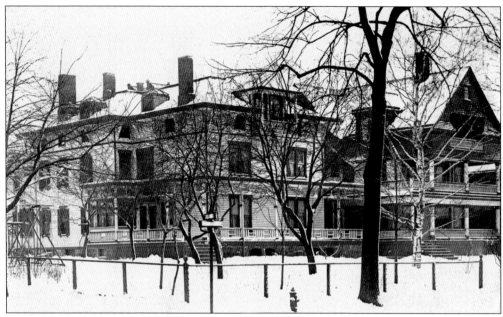

EAST 115TH STREET IN LITTLE ITALY, 1920S. Although they supported the United States, many Clevelanders of Italian ancestry saw Benito Mussolini's rise to power in Italy during the early 1920s to be a good thing for their homeland. Many were willing to overlook the uglier side of fascism if it improved roads, created jobs, and made the trains run on time back in Italy. (Little Italy Heritage Museum.)

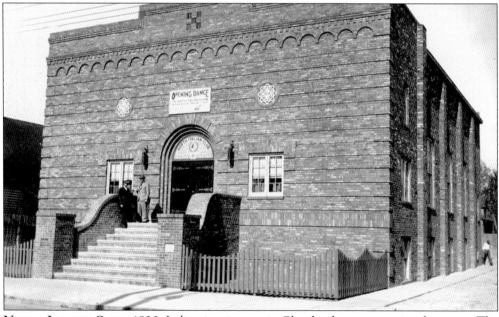

NORTH ITALIAN CLUB, 1930. Italian immigrants in Cleveland were a very insular group. The established residents helped the new arrivals get acclimated to the city and helped to fund housing and small business ventures. Many of these organizations, such as the North Italian Club, developed into social and political groups. Although several of these clubs still exist, today they have but a handful of members. (Cleveland State University/Cleveland Press Collection.)

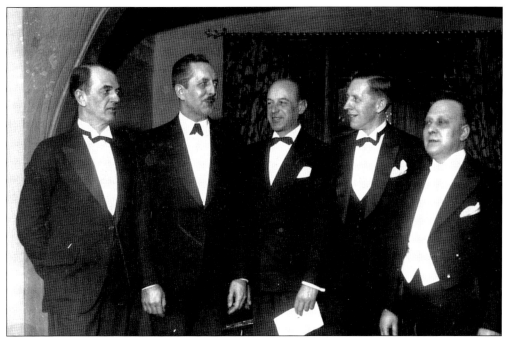

DANTE ALIGHIERI SOCIETY, 1935. A large percentage of the Italian American community between the wars feared losing their Italian heritage to Americanization. The Cleveland branch of the Dante Alighieri Society was just one of many organizations designed to promote Italian language, culture, and history in northeast Ohio. (Cleveland State University/Cleveland Press Collection.)

NEWSPAPERS. At one time, Cleveland had two Italian-language newspapers: *La Voce del Popolo Italiano*, founded in 1904 by Olindo G. and Fernando Melaragno, and *L'Araldo*, founded in 1938. The former continued until 1944; the latter ceased operations in 1959. (Cleveland State University/Cleveland Press Collection.)

CORNELL AND RANDOM ROADS, 1928. By the late 1920s, the Little Italy neighborhood had grown to include many of the large Victorian-style houses that one finds there today. With the advent of the automobile, brick-paved thoroughfares replaced dirt roads. (Cleveland State University/Cleveland Memory Project.)

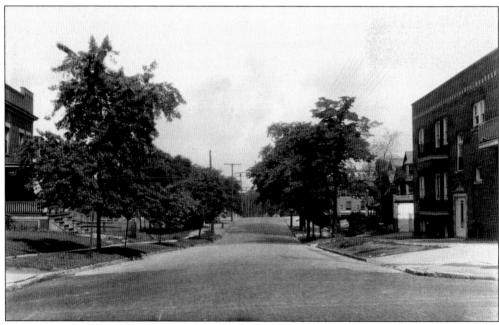

ADELBERT AND MURRAY HILL ROADS, 1928. Murray Hill Road, once Cozad Street, was named after the street of the same name in New York's Little Italy neighborhood. During a rise of Italian nationalism in the 1930s, there was an attempt to change the name to Marconi Avenue, but the proposal was defeated. (Cleveland State University/Cleveland Memory Project.)

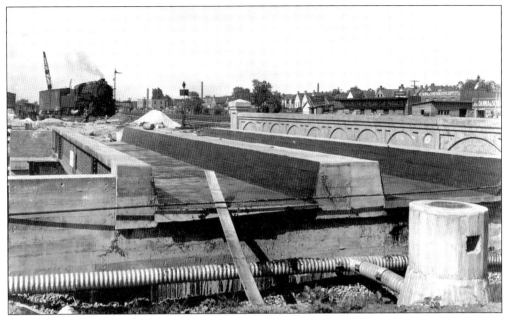

THE MAYFIELD ROAD OVERPASS. As industry moved farther east in Cleveland so did the railroad. The Cleveland Union Terminal of the Nickel Plate Railroad built a new facility on the border of Little Italy in the late 1920s and provided a number of jobs for new immigrants. The Mayfield Road Overpass still serves as Little Italy's northern boundary. (Cleveland State University/Cleveland Memory Project.)

EASTERN EDGE OF LITTLE ITALY, 1928. By the late 1920s, the Little Italy neighborhood had extended west to Cornell Road and south to Edgehill Road. With the two natural boundaries of Lake View Cemetery to the east and the Mayfield Road Bridge to the north, the neighborhood became an insular, self-contained community. (Cleveland State University/Cleveland Memory Project.)

TWO THOUSAND CASES OF BEER CONFISCATED, 1930. Like most ethnic groups in Cleveland, the city's Italian community was not a big supporter of Prohibition. It is easy to see why. Wine is an integral part of Italian culture, accompanying religious festivals and even the most humble family meal. (Cleveland State University/Cleveland Press Collection.)

CONFISCATED BARRELS OF WHISKEY IN CLEVELAND, 1931. Throughout Cleveland, liquor violations accounted for as many as 30 percent of the arrests made during the 1920s, and Murray Hill, during this period, suffered an explosion of the latent prejudice against the neighborhood. During the 1920s, Cleveland safety forces set up roadblocks at the entrances to Little Italy and searched cars and persons for liquor without warrants. (Cleveland State University/Cleveland Press Collection.)

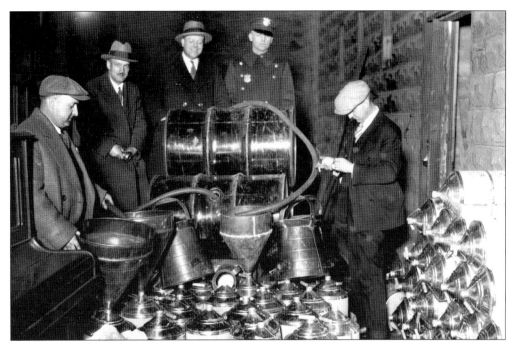

A FEDERAL AGENT RAID, 1931. The Prohibition era also gave rise to a less savory element in Cleveland, and in Little Italy. The so-called Mayfield Mob (named for its meetings on Mayfield Road in Little Italy) was a group of mostly Italian Americans who became involved in bootlegging and illegal gambling in the 1920s and 1930s. These individuals represented a minority of the mostly hardworking and law-abiding citizens in the neighborhood. (Cleveland State University/Cleveland Press Collection.)

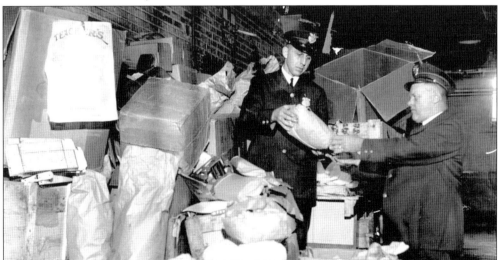

RAID ON A LIQUOR PACKAGING PLANT, 1931. Cleveland's Italian crime leaders entered into a partnership with the area's Jewish syndicate in the early 1930s, and both groups seemed to have benefited from the relationship. In the late 1970s, the Italian group became embroiled in a power struggle with local Irish crime leaders. After the car-bombing deaths in 1977 of Danny Greene and John Nardi and the subsequent prosecutions, organized crime in Cleveland became much less visible. (Cleveland State University/Cleveland Press Collection.)

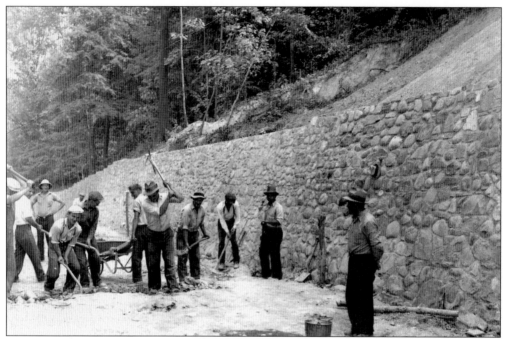

WPA PROJECT IN BEDFORD RESERVATION. The WPA was a lifeline for the over 50 percent of Little Italy residents who were out of work during the Depression of the late 1920s and early 1930s. The WPA in Cleveland sponsored a variety of skilled and unskilled jobs, such as the work on the Bedford Reservation of the Cleveland Metroparks (above). (Cleveland State University/Cleveland Press Collection.)

GETTING A WPA PAYCHECK. During its seven-year existence, the WPA provided jobs for a wide variety of area residents. At the height of the program in October 1938, over 78,000 Cuyahoga County men and women were employed by the WPA. The average paycheck was $80 for two weeks' work in a month. (Cleveland State University/Cleveland Press Collection.)

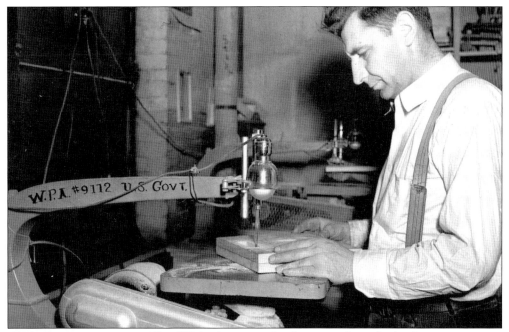

WPA Workshop, 1940. The WPA also created a large number of jobs for artists, actors, musicians, and writers. Among the visual art programs in and around the city were initiatives at the Cleveland Zoo and the Cleveland Cultural Gardens as well as art for the new Cleveland public housing projects. (Cleveland State University/Cleveland Press Collection.)

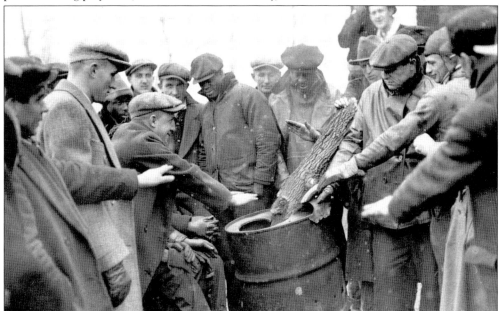

WPA Workers in Cleveland. By November 1939, WPA employment in Cleveland had decreased to around 30,000, largely due to area factories recalling their employees. By 1942, the program had been phased out completely in the city. The WPA, while it existed, was vital to the area's ethnic population, including Little Italy residents. (Cleveland State University/Cleveland Press Collection.)

INDUCTEES LEAVING FOR WORLD WAR II. The advent of World War II brought a new affluence to Little Italy, as residents found work in area factories. It was also a sad time, as over 300 members of Holy Rosary parish saw combat during the war and residents with family and friends in Italy anguished about the fighting in their homeland. (Little Italy Heritage Museum.)

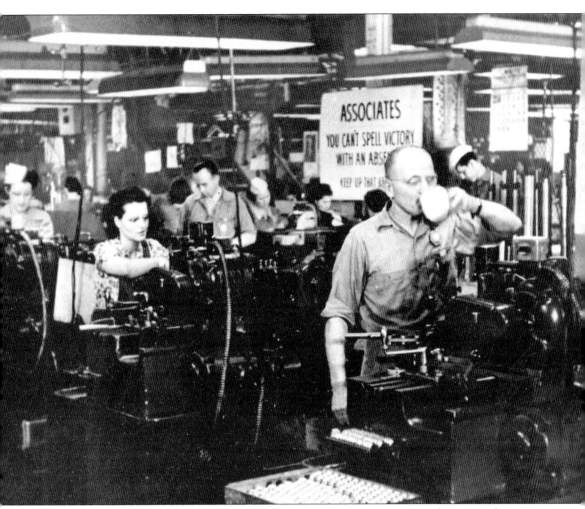

CLEVELAND FACTORY DURING WORLD WAR II. The war years were a time of sorrow and tension as the old neighborhood worried about its sons (and a few daughters) serving overseas. The war also marked a turning point for Little Italy, although few knew it at the time. Aided by the GI Bill, returning service personnel had the education and the means to move out of Little Italy, mostly to the area's eastern suburbs. (Little Italy Heritage Museum.)

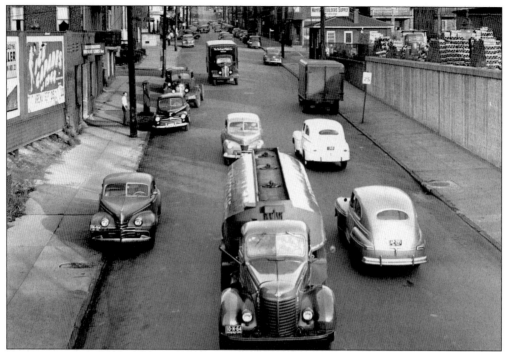

MAYFIELD ROAD. Little Italy of the 1940s was a self-contained "island," with its own groceries, a drugstore, a theater, and many restaurants. Alta House provided social activities as well as social services. Few residents owned a car and most were content to stay within the friendly confines of the old neighborhood. (Little Italy Heritage Museum.)

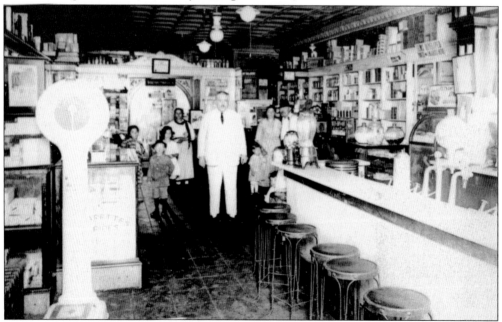

ITALIAN DRUG STORE. The Italian Drug Store, on Mayfield Road, was a popular meeting place in mid-20th-century Little Italy. Longtime residents recall going there for a soda after school and weighing themselves for a nickel on the huge drugstore scale. (Little Italy Heritage Museum.)

MAYFIELD CAFÉ, 1946. Small family-run bars, like the Mayfield Café (above), were common all around Little Italy in the post-Prohibition era. They were good places to keep in touch with friends and share the news of the day. (Little Italy Heritage Museum.)

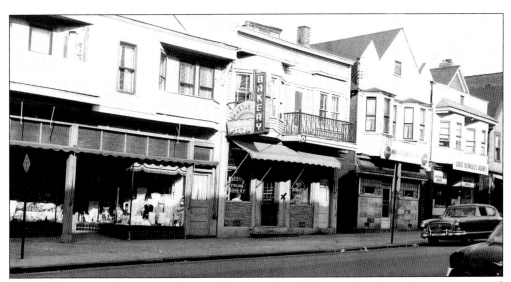

ALONG MAYFIELD ROAD, 1947. Mayfield Road in the 1940s was a bustling, vibrant commercial district. Businesses, such as Presti's Bakery (above), were daily destinations for many Little Italy families. The usual household routine included stops at the meat market, bakery, and dry goods store. (Cleveland Public Library photograph collection.)

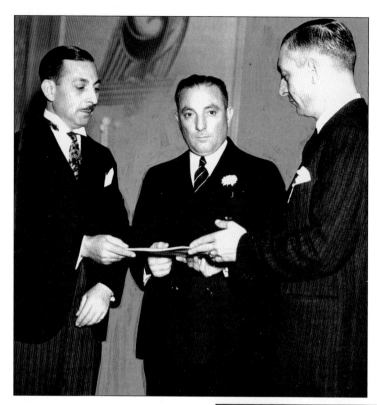

ITALIAN CONSUL. The Cleveland-based Italian consul was a vital link between the old country and the growing Italian American community. Pictured is Dr. Romeo Montecchi (center), Italian consul in Cleveland from 1936 to 1941. (Cleveland State University/Cleveland Press Collection.)

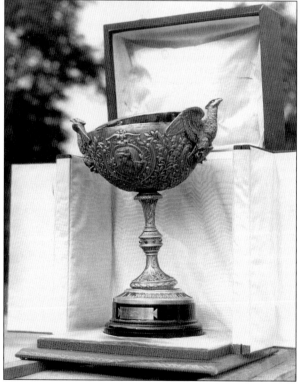

SILVER CUP GIVEN TO CLEVELAND'S ITALIAN AMERICAN COMMUNITY. Cleveland's Italian American community, in general, was pleased with the improvements in its homeland under the fascist Benito Mussolini regime, even receiving awards for supporting the Italian government financially. This enthusiasm halted abruptly when Italy declared war on France and England on June 10, 1940. (Cleveland State University/Cleveland Press Collection.)

Three
CHANGE AND EVOLUTION

After World War II ended in 1945, the Little Italy neighborhood began to change rapidly. Returning veterans had seen the world and few were content to settle again within the confines of the old neighborhood. In addition, the GI Bill provided them with the means to go to college, something most of their parents had been unable to do.

An increase in area factory jobs, created in the war boom of the early 1940s, continued as buyers in the 1950s lusted for new cars, appliances, televisions, and other consumer goods. New roads made it easier to get around northeast Ohio, and one could live in the far eastern suburbs and still work in downtown Cleveland. All of these factors combined to draw families away from Little Italy, where they grew up.

Still, the neighborhood did not disappear, as did some of Cleveland's other ethnic communities. Loyalty to Little Italy was still strong, and many, if not most, families continued to visit relatives and shop in the markets of the old neighborhood.

In the 1960s and 1970s, a new type of resident began arriving in Little Italy—students and professional men and women, drawn by the neighborhood's ever-expanding neighbors, Case Western Reserve University, and University Hospitals of Cleveland.

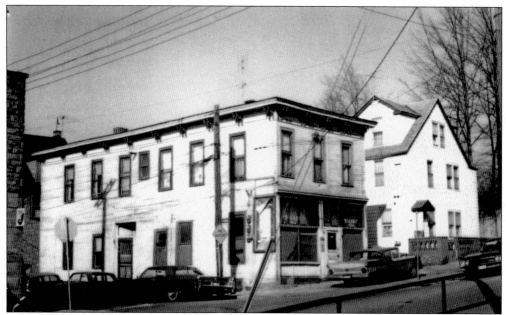

MAYFIELD ROAD, 1954. The end of World War II and the relative affluence of the 1950s and 1960s caused many families to move from Little Italy to new houses in Cleveland's growing eastern suburbs, such as Mayfield Heights, Lyndhurst, and Willowick, leaving the business district on Mayfield Road to languish. (Cleveland State University/Cleveland Press Collection.)

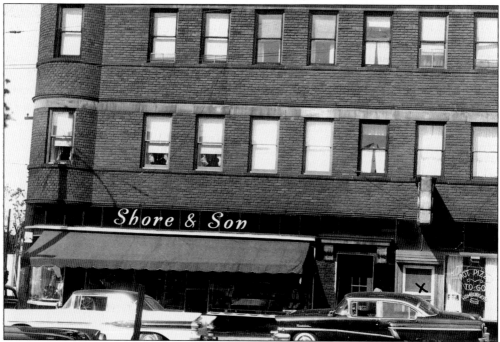

SHORE AND SON, 1954. The stores on Mayfield Road did not disappear completely after the exodus to the suburbs in the late 1950s and early 1960s. Many loyal Italians and former residents returned to the neighborhood to support Little Italy restaurants, groceries, and bakeries. (Cleveland Public Library photograph collection.)

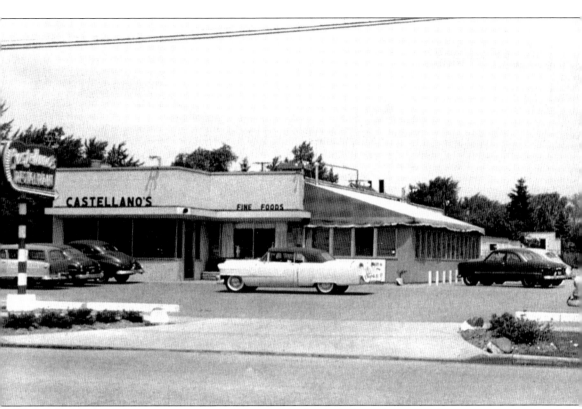

CASTELLANO'S RESTAURANT, 1958. Many of the Little Italy tradesmen and store owners took their businesses with them when they moved to the suburbs. Businesses such as Alesci's Market and Castellano's Restaurant on Mayfield Road (above) have their roots in Little Italy. (Cleveland State University/Cleveland Memory Project.)

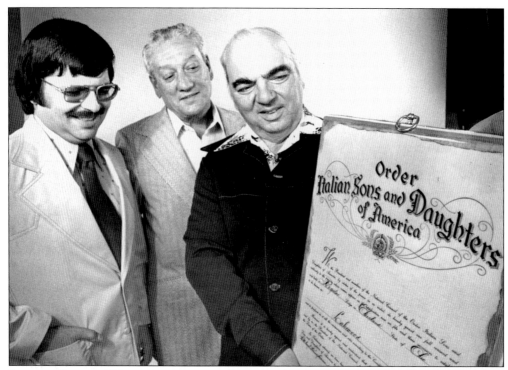

ITALIAN LEADERS DECORATED BY THE ITALIAN GOVERNMENT, 1959. Cleveland's Italian American community maintained close ties to the Italian government. The city even had a consulate office until 1978. Here members of the Sons of Italy are recognized by the Italian government for their work in preserving Italian culture and language in northeast Ohio. (Cleveland State University/Cleveland Press Collection.)

MAYFIELD ROAD, 1958. At its peak in 1960, Little Italy was home to approximately 5,800 residents, 90 percent of whom were Italian or of Italian descent. Just 10 years later, the neighborhood's population had decreased to 3,800 residents, with just 75 percent of Italian extraction. (Cleveland Public Library photograph collection.)

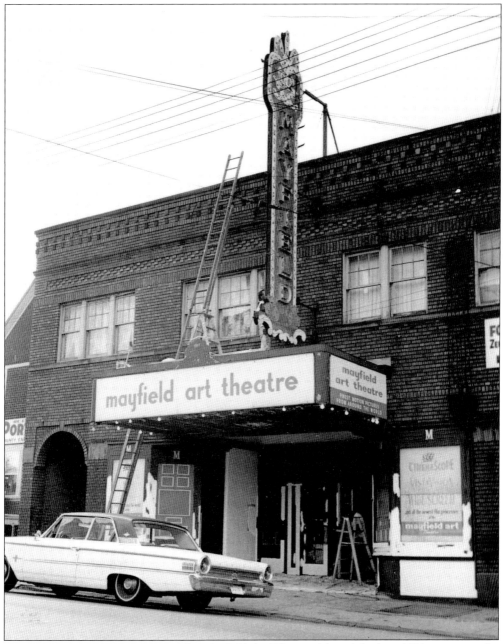

MAYFIELD ART THEATRE, 1976. The Mayfield Art Theatre (above), built in 1923, was a popular revival movie house in the mid-1970s. The 500-seat venue would draw visitors from all over the city to see screenings of classics like *Singing in the Rain* and *An American in Paris*. The theater closed in 1986, a casualty of cable television and movie rentals. Today the theater is empty, its fate still undecided. (Little Italy Heritage Museum.)

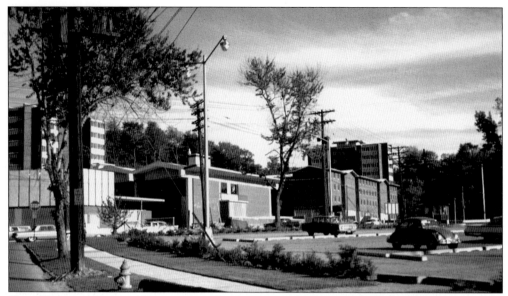

CASE WESTERN RESERVE UNIVERSITY DORMITORIES ON ADELBERT ROAD, 1964. Dormitories and fraternity and sorority houses, affiliated with University Circle's Case Western Reserve University, started to move into Little Italy in the 1960s, along Murray Hill and Adelbert Roads. The part-time residents who lived there brought new energy to the neighborhood and helped keep struggling restaurants and retailers afloat. (Cleveland State University/Cleveland Memory Project.)

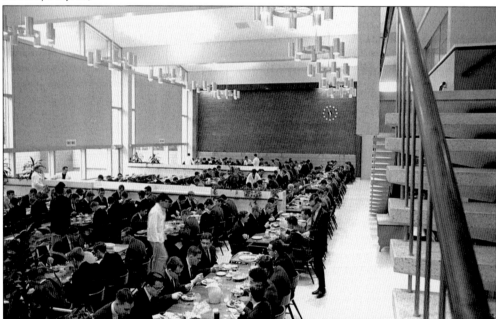

MURRAY HILL COMMONS, 1967. University students became a vital part of Little Italy in the 1960s as Case Western Reserve University built new fraternity houses and dormitories, such as Murray Hill Commons (above), along the western end of Murray Hill Road. Students remain a common sight in the neighborhood's pizza houses and groceries. (Cleveland State University/ Cleveland Press Collection.)

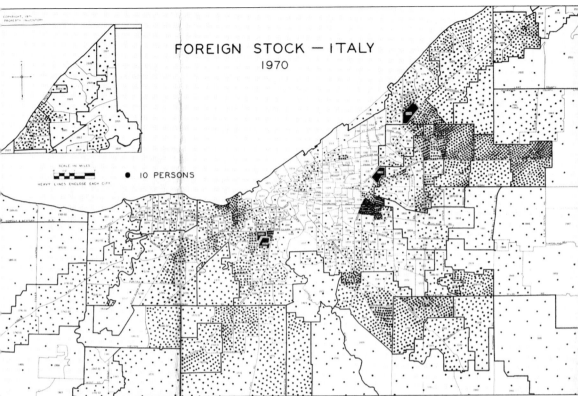

ITALIANS IN CLEVELAND. Cleveland's Italian American community by 1970 was still concentrated primarily on the city's east side, but the residents of "the Hill" had started to migrate to the area's eastern suburbs, including Mayfield Heights, Willowick, and Lyndhurst. (Cleveland State University/Cleveland Press Collection.)

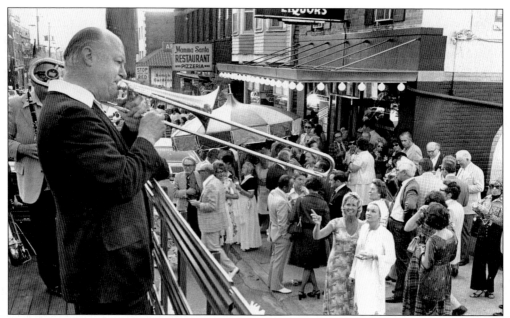

ROAMIN' CARNIVAL, 1975. The 1970s brought transition to Little Italy, as the neighborhood struggled to reinvent itself as a tourist mecca. Events such as the Roamin' Carnival, a fund-raiser for the Cleveland Institute of Music, exposed residents from other parts of Cleveland to the charms of the old neighborhood and helped to start Little Italy's renaissance. (Cleveland State University/Cleveland Press Collection.)

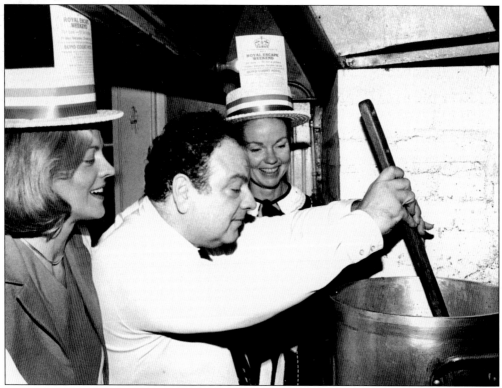

UNIVERSITY HOSPITALS OF CLEVELAND. University Hospitals, another of Little Italy's neighbors, has gradually bought up land surrounding the neighborhood. Today the hospital complex extends to just north of the Mayfield Road railroad bridge boundary. University Hospitals, as northeast Ohio's second-largest employer, also provides jobs for many of today's Little Italy residents. (Cleveland State University/Cleveland Press Collection.)

RAINBOW BABIES AND CHILDREN'S HOSPITAL OF UNIVERSITY HOSPITALS, 1968. University Hospitals of Cleveland and the surrounding neighborhoods, including Little Italy, maintain an uneasy coexistence. The huge medical complex has already overrun many of the historic streets of University Circle and threatens to inch into the old neighborhood. (Cleveland State University/Cleveland Press Collection.)

Four

THE INSTITUTIONS

Little Italy's success as a neighborhood and as a community was—and is—due in large part to its institutions. As early as the late 19th century, Holy Rosary Church welcomed new arrivals into the community and helped them get acclimated to living in Cleveland with financial assistance, education, and language training, as well as spiritual guidance. As the needs of the neighborhood evolved, so did the church, with projects like adding a grade school and later converting it into a Montessori school.

The church-sponsored Feast of the Assumption has been a favorite Little Italy occasion for over 70 years. The unique festival successfully combines the secular with the religious to the joy of everyone involved.

Alta House, innovative when it began in the early 20th century, remains to this day one of Cleveland's most successful community centers. The center, created with funding from Standard Oil baron and friend to the neighborhood John D. Rockefeller, has also evolved. Alta House began offering assistance for those newly arrived from overseas and their children and is today noted for its senior citizen programs.

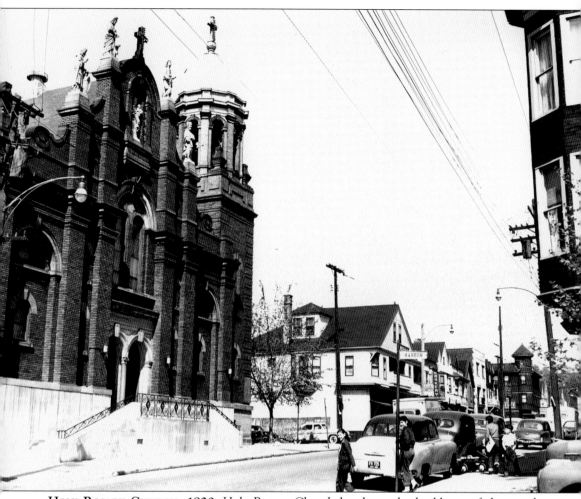

HOLY ROSARY CHURCH, 1920. Holy Rosary Church has been the backbone of the mostly Catholic Little Italy community since the church was established in 1892. Constructed on land deeded the parish by the Protestant Joseph Carabelli for $1, Holy Rosary was, and continues to be, the social and religious center in Little Italy. The church-sponsored Feast of the Assumption, held annually around August 15, draws over 100,000 visitors each year and provides funds for church charities and neighborhood programs. (Cleveland State University/Cleveland Press Collection.)

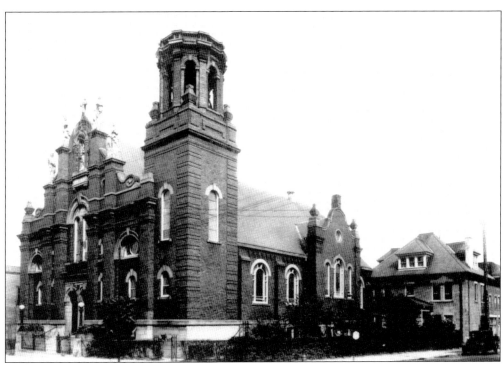

HOLY ROSARY CHURCH, 1910. The original, hastily constructed church was replaced with the current structure, built adjacent to the original church from 1901 to 1909. The "new" Holy Rosary (above) was dedicated on November 9, 1909. (Cleveland State University/Cleveland Memory Project.)

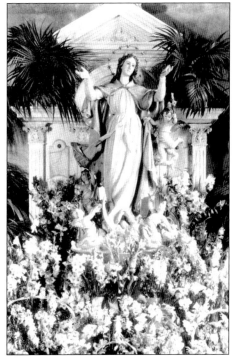

INTERIOR OF HOLY ROSARY CHURCH, 1929. The interior of Holy Rosary Church reflects the neighborhood's Italian heritage. One of the highlights is the large statue of Mary, pictured here adorned with flowers during the Feast of the Assumption. (Cleveland State University/ Cleveland Press Collection.)

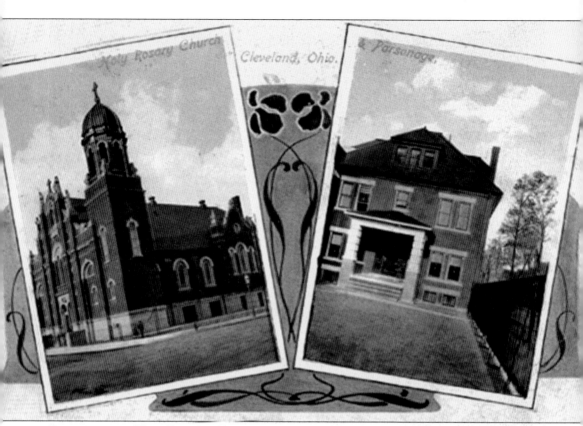

PARSONAGE AT HOLY ROSARY CHURCH, 1929. In addition to religious services, Holy Rosary offered religious classes for young and older members, athletic programs, language classes, and even a medical dispensary in the early 20th century. (Cleveland State University/Cleveland Memory Project.)

FR. JOSEPH TRIVISONNO. Fr. Joseph Trivisonno became pastor of Holy Rosary Church in 1929 and guided the parish through the dark days of the Depression, when over half of the neighborhood families received some kind of relief. He made the church a refuge for those in need, and attendance at mass actually increased during his tenure. (Little Italy Historical Museum.)

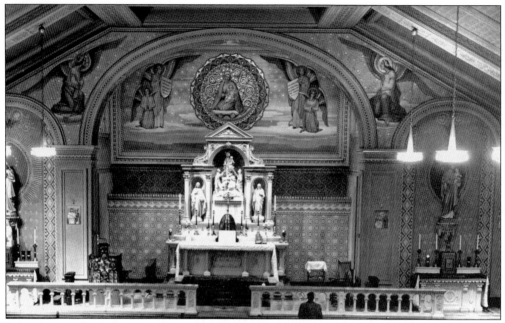

INTERIOR OF HOLY ROSARY CHURCH, 1961. In addition to consolidating the community at Holy Rosary, Fr. Joseph Trivisonno renovated the church extensively and brought nuns from the community of Maestre Pie Filippini in Italy to work in the parish. (Cleveland State University/Cleveland Press Collection.)

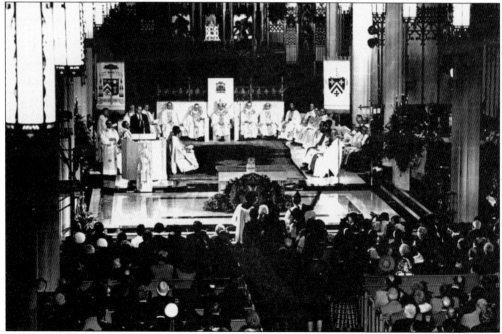

INSTALLATION OF BISHOP PILLA AT HOLY ROSARY CHURCH, 1981. One of the high points in Holy Rosary Church history is the installation of Little Italy native Fr. Anthony Pilla as bishop of Cleveland in 1981. Bishop Pilla was the first bishop of Cleveland to be of Italian descent. (Cleveland State University/Cleveland Press Collection.)

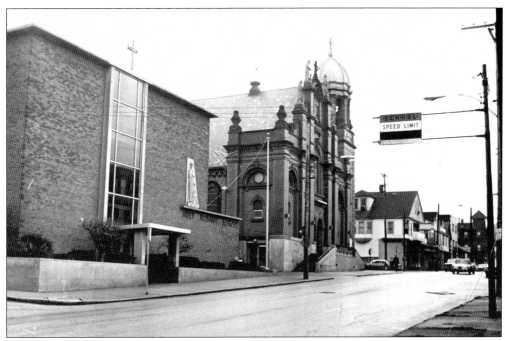

HOLY ROSARY SCHOOL, 1967. The Holy Rosary parochial school was established in 1945 under the guidance of Fr. Joseph Trivisonno. At its peak, around 1960, the school had an enrollment of approximately 400 students. The school closed in 1993, and the building is now a Montessori school. (Cleveland State University/Cleveland Press Collection.)

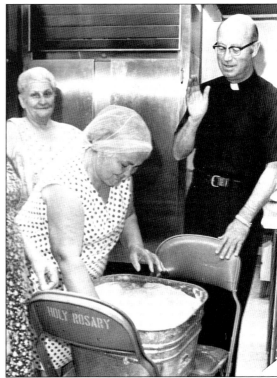

FR. GAETANO MENEGATTO, 1973. Fr. Gaetano Menegatto (right), born in Italy and ordained in New Mexico in 1942, guided the Holy Rosary parish from 1977 to 1989, a time of transition. Prior to his posting in Little Italy, Father Menegatto served as a teacher and spiritual advisor at Elyria Catholic High School. (Cleveland State University/Cleveland Press Collection.)

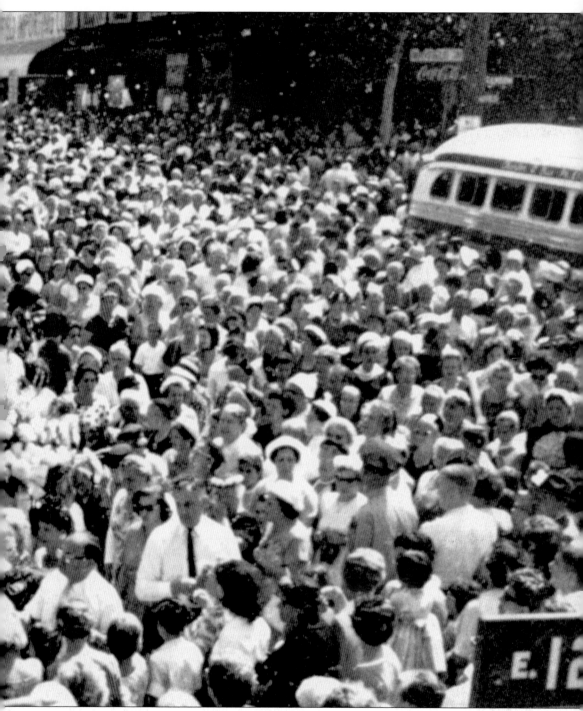

FEAST OF THE ASSUMPTION, 1940. Just as everyone is Irish on St. Patrick's Day, in Cleveland everyone is Italian for the Feast of the Assumption. Cleveland's feast, which began in the early 20th century, is held each year for four days surrounding August 15, the Catholic high holy day of assumption. A similar event was popular in the Campobasso province of southern Italy, from which many of Little Italy's early residents hailed. The festival is a delightful combination of

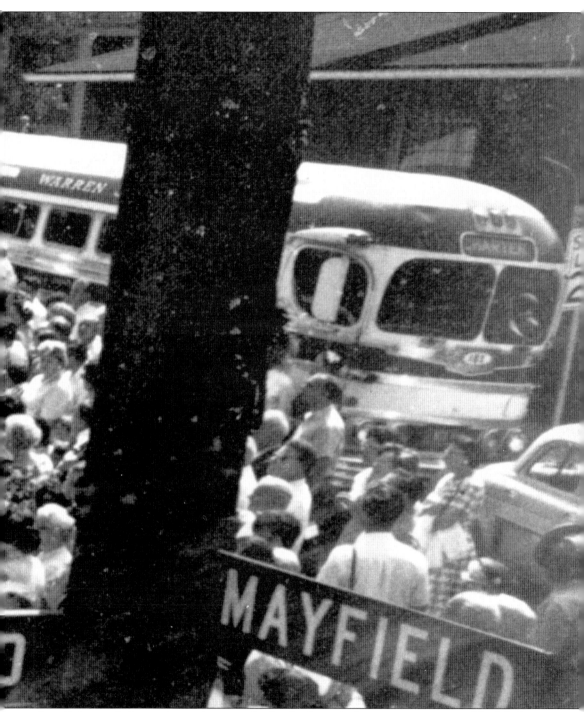

the religious and the secular, with carnival rides, food stands, live entertainment, and high holy mass on the 15th, followed by a solemn parade where the Virgin Mary is carried throughout the neighborhood. Today the event draws over 100,000 revelers each year. Admission is free. (Cleveland State University/Cleveland Press Collection.)

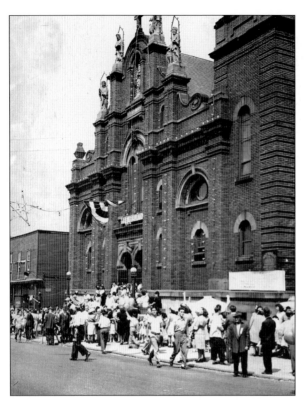

HOLY ROSARY CHURCH ON ASSUMPTION DAY, 1946. The Feast of the Assumption begins each year with high mass at Holy Rosary Church, followed by a procession of the Virgin, where a statue of Mary is carried throughout the streets of Little Italy, accompanied by neighborhood marchers of all ages. (Cleveland Public Library photograph collection.)

PARISH LADIES MAKING PIZZA FOR FEAST. The procession of the Virgin Mary ends with a fireworks display each year, after which all the marchers are treated to a traditional dinner of cavatelli in red sauce, prepared by the women of Holy Rosary parish. (Cleveland State University/Cleveland Press Collection.)

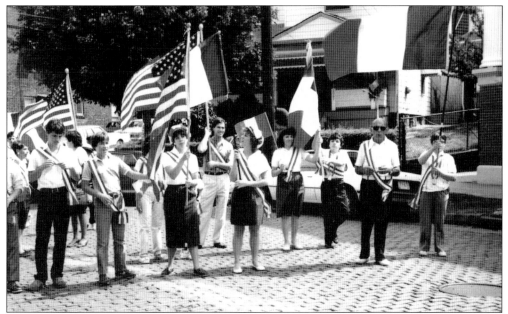

FEAST OF THE ASSUMPTION, 1962. A portion of the considerable proceeds from the annual Feast of the Assumption goes to assist the Holy Rosary Church in its mission. In addition to the funds raised through the rides and food and beverage sales, it is customary during the feast parade to pin money onto the garments of the statue of Mary. This money also goes to the church. In recent years, the funds have helped maintain the church and fund its senior outreach program. (Cleveland State University/Cleveland Press Collection.)

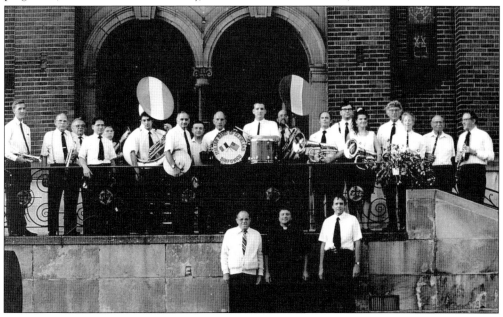

FEAST OF THE ASSUMPTION, 1983. Originally Holy Rosary Church hosted several street festivals and processions, including the Feast of St. Anthony's each June and the Feast of the Holy Rosary, held each October. The only one that remains of these celebrations is the Feast of the Assumption in August. (Little Italy Heritage Museum.)

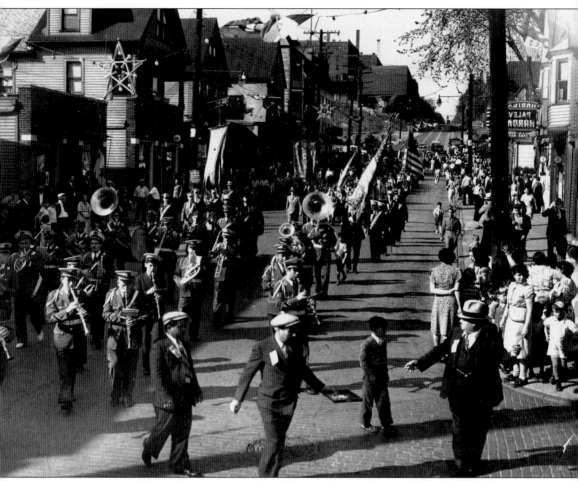

MURRAY HILL COLUMBUS DAY PARADE, 1938. Columbus Day, made a state holiday in Ohio through the efforts of Joseph Carabelli, is a time of celebration in Little Italy. Activities include a parade through the streets and a special mass at Holy Rosary Church. The Columbus Day tradition continues into the 21st century. (Cleveland State University/Cleveland Press Collection.)

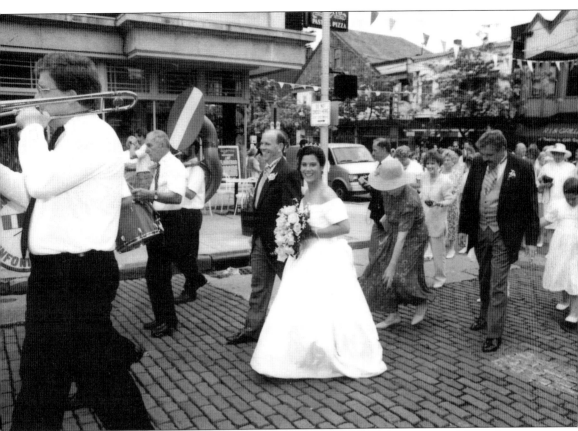

A MURRAY HILL WEDDING. The celebrations of life—weddings, baptisms, and funerals—are community affairs in tight-knit Little Italy. It is not unusual for the affair to spill out onto the neighborhood streets, as with the wedding pictured above. As with all Italian communities, family and faith are the two most important elements. Little Italy's immigrant community thrived by helping family and friends arriving from the old country. That "we support our own" sentiment still prevails in the neighborhood. (Little Italy Heritage Museum.)

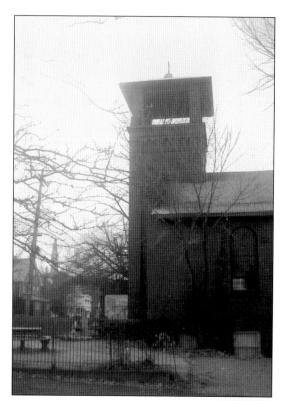

ST. JOHN'S BECKWITH MEMORIAL CHURCH. Although the majority of Little Italy's early residents were Roman Catholic, there was a sizeable minority of Italian Protestants living in the neighborhood. St. John's Beckwith Memorial Church, on Murray Hill Road, was their church. Although he contributed the land on which the Holy Rosary Church was built, early Little Italy patron Joseph Carabelli was a Protestant and attended St. John's Beckwith. In fact, he donated the baptismal font for the church. Built in 1907, the Presbyterian church held services in both English and Italian until the early 1960s, when it merged its declining congregation with the Church of the Covenant a mile away on Euclid Avenue at University Circle. Today St. John's Beckwith is a school, the Lyceum, and a striking art gallery, a popular stop on the seasonal Murray Hill Art Walk. The former church retains much of its original woodwork, the choir loft, and many early-20th-century leaded glass windows. (Author's collection.)

LYCEUM. The Lyceum, located on Murray Hill Road, is a new Little Italy institution. The school, opened in 2003, combines classical Catholic education with an appreciation of the arts. The school's historic redbrick building, the former St. John's Beckwith Memorial Church, is also a popular venue for small concerts and art exhibits. (Author's collection.)

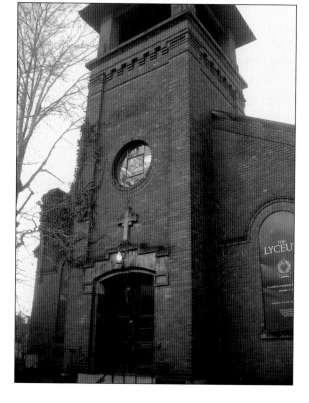

ALTA HOUSE. Alta House is a Little Italy institution, second only in importance to Holy Rosary Church. The organization was founded in 1898 with the financial assistance of then Cleveland businessman John D. Rockefeller, who named it after his daughter, Alta. Alta House initially provided services and education for young children but grew to include a wide range of community services and social activities. (Photograph by F. W. Smith/Cleveland Public Library photograph collection.)

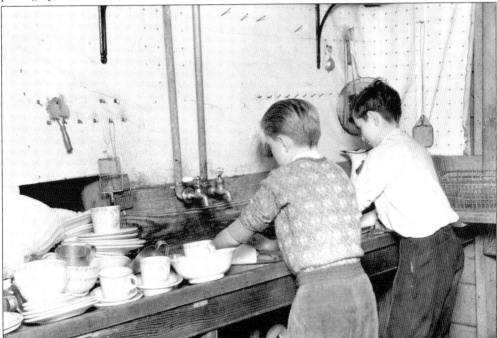

KITCHEN AT ALTA HOUSE. Life at Alta House was not all fun and games. Members of the youth groups were required to help with the center's chores, such as washing dishes and cleaning up the kitchen. (Cleveland State University/Cleveland Press Collection.)

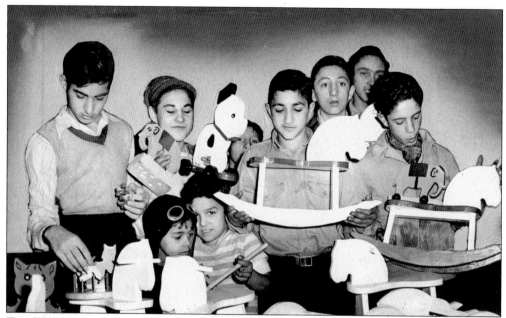

TOY WORKSHOP AT ALTA HOUSE, 1932. At its height in the mid-20th century, Alta House's services included a school for crippled children, a medical dispensary, a gymnasium and public baths, a kindergarten, social and educational classes for adults, a library, a swimming pool, and a full schedule of after-school activities. The institution quickly grew from a single structure in 1898 to a three-building complex in 1905. (Cleveland State University/Cleveland Press Collection.)

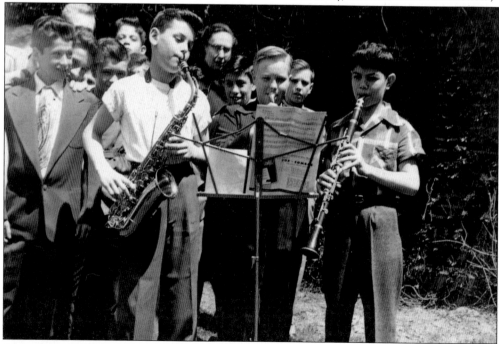

ALTA LIBRARY BAND, 1952. Music played an important part in the Alta House program, almost from its inception. A variety of bands and vocal groups for young residents kept the neighborhood youth occupied. (Little Italy Heritage Museum.)

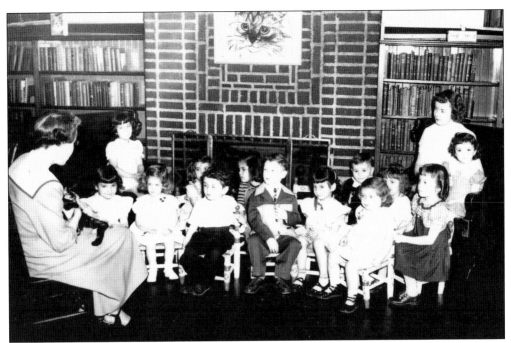

ALTA HOUSE CHILDREN'S ROOM. Alta House was a "home away from home" for many young residents of Little Italy. One of the most popular activities was the weekly story hour by the fireplace in the center's library. (Little Italy Heritage Museum.)

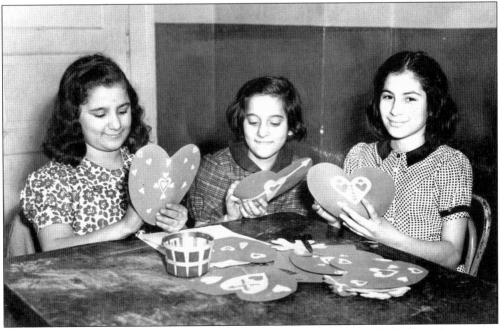

CRAFTS AT ALTA HOUSE, 1950s. Alta House was the Boys and Girls Club to the younger residents of Little Italy in the mid-20th century. Sports, crafts, and other activities were a key part of this program, with area retailers and other sponsors helping with supplies, uniforms, and equipment. (Little Italy Heritage Museum.)

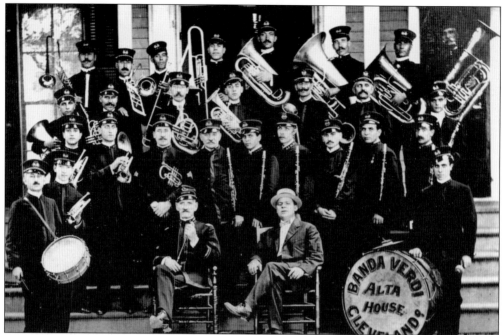

ALTA HOUSE BAND. Music at Alta House was not limited to the children. The facility sponsored a full brass band during the 1930s and 1940s and even brought bandleaders over from Italy to organize the program. (Little Italy Heritage Museum.)

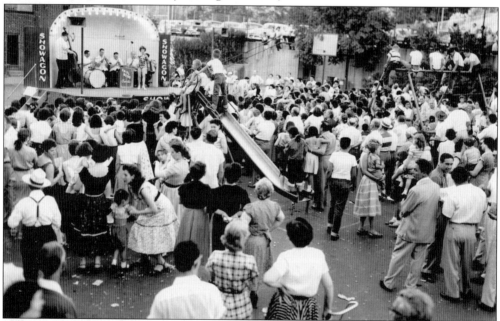

SHOWAGON AT ALTA HOUSE, 1950. Alta House offered programs and events for adults, also. The community house organized theater, Italian- and English-language classes, and musical events. One popular annual event was the Showagon, which set up in the Alta House parking lot and featured entertainers in a variety of music genres. (Cleveland State University/Cleveland Press Collection.)

ALTA HOUSE AFTER FIRE, 1981. Alta House has survived the shifting of many Italian Americans from the old neighborhood to the Cleveland suburbs as well as a series of fires that destroyed the main building in 1981. (Cleveland State University/Cleveland Press Collection.)

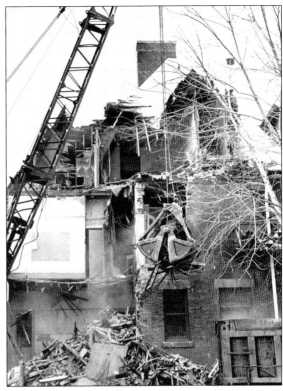

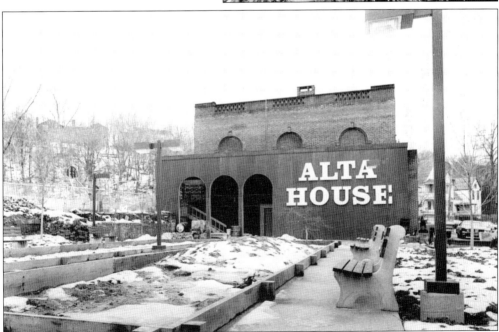

NEW ALTA HOUSE, 1982. Alta House rose from the ashes of the 1981 fires with a new building on Mayfield Road in 1982. The center continues to be one of Cleveland's most viable neighborhood centers and has expanded its services to include meals and social activities for the elderly. (Cleveland State University/Cleveland Press Collection.)

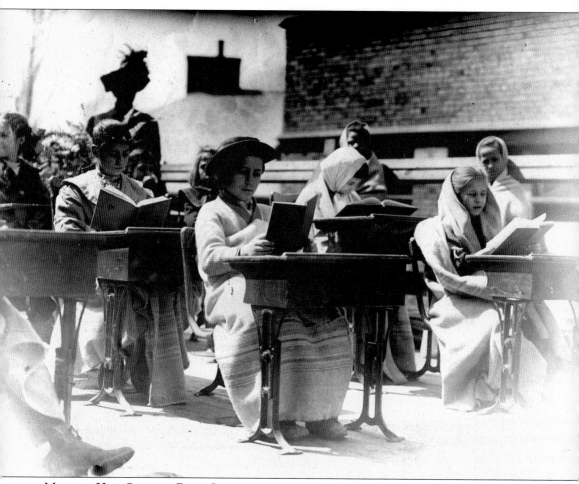

MURRAY HILL SCHOOL, ROOF SCHOOL, 1912. Murray Hill School, originally called Brandon School, began as a four-room frame structure. An eight-room brick annex was added in 1903. Every available space was used. They even put classrooms on the roof of the building. (Cleveland State University/Cleveland Press Collection.)

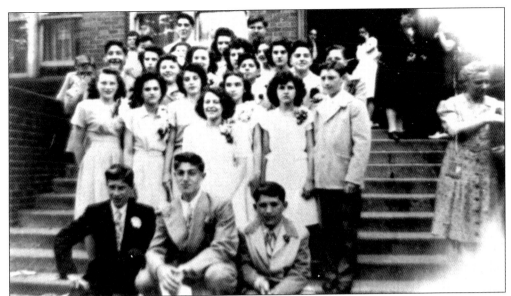

EIGHTH-GRADE GRADUATION CLASS AT MURRAY HILL SCHOOL. Murray Hill School was one of two schools in Little Italy during the mid-20th century, the other being the parochial school at Holy Rosary Church. The large redbrick school on Murray Hill Road was part of the Cleveland public school system and taught grades kindergarten through eight. (Little Italy Heritage Museum.)

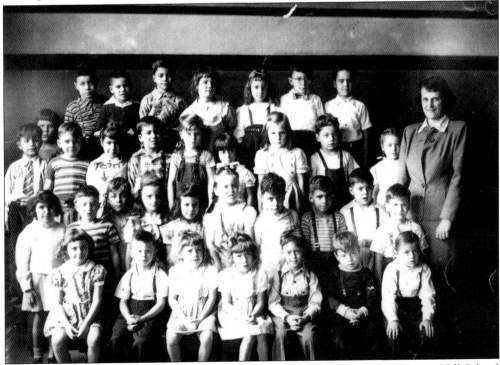

MURRAY HILL SCHOOL CLASS OF 1948. In the late 1940s and early 1950s, Murray Hill School was a thriving, vital part of the Little Italy community. The school had an enrollment of over 1,000 students at its peak in the early 1950s. (Little Italy Heritage Museum.)

TEACHERS FROM MURRAY HILL SCHOOL, 1950S. The teachers of Murray Hill School, led from 1936 to 1956 by principal Florence Graham (second from left), were some of the most respected members of the community. Until the late 1950s, the teachers were required to remain

unmarried. Graham was practically synonymous with Murray Hill School. She led the school during its heyday in the 1930s, 1940s, and 1950s, and many in the neighborhood called her "Miss Murray Hill." Graham died in 1988 at the age of 93. (Little Italy Heritage Museum.)

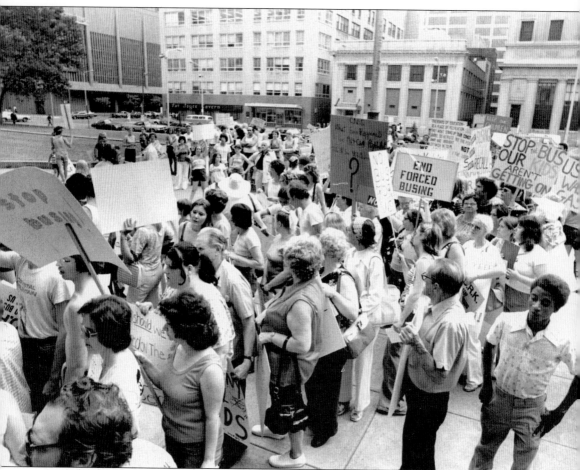

CONCERNED PARENTS AT THE CLEVELAND PUBLIC SCHOOL ADMINISTRATION BUILDING, 1978. In his ruling in the landmark Cleveland school desegregation case, *Reed v. Rhodes*, in 1976, Judge Frank Joseph Battisti cited Murray Hill School as an example of how "school officials deliberately caused segregated schools." Concerned parents from all over the school district congregated near the school administration building in downtown Cleveland to learn more about the new school busing program, mandated by the ruling. Few parents, black or white, relished the thought of their young children traveling for hours across town to go to school each day. Holy Rosary School received 14 new enrollees the week that Battisti's decision was announced, even though diocesan policy prohibited using the city's Catholic schools to avoid the Cleveland desegregation order. (Cleveland State University/Cleveland Press Collection.)

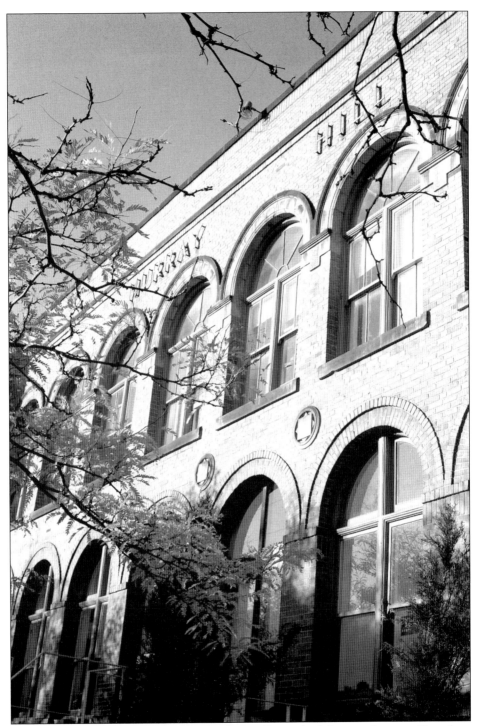

MURRAY HILL SCHOOL. Murray Hill School's enrollment had decreased to just 42 students in grades kindergarten through eight before the school closed in 1978. The building sat empty for almost a decade before it was transformed into artist lofts, galleries, and condominiums in the late 1980s. Today it houses 35 artist galleries as well as offices and residences. (Terry M. Goodman)

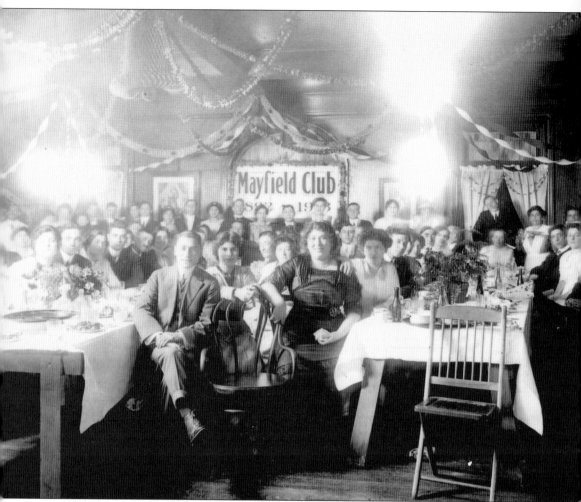

MAYFIELD CLUB, 1913. The Mayfield Club was another of the Italian American social clubs in the Cleveland area. Others included the North Italian Club, the Calabrese Club, the Italian Workers Society, and the St. Anthony's Club. Most clubs focused on a common denominator, such as workers in the same industry or immigrants who came from the same part of Italy. (Little Italy Heritage Museum.)

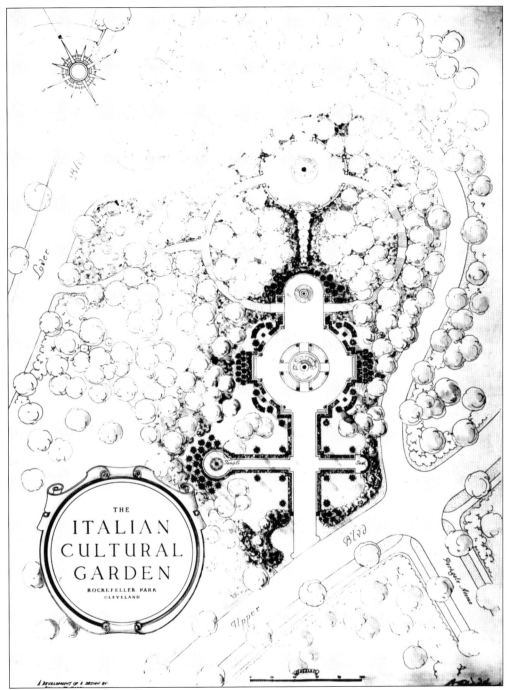

ITALIAN CULTURAL GARDEN. An example of the pride and importance of Cleveland's Italian community was the addition of the Italian Cultural Garden to the collection of ethnic gardens along Rockefeller Park, just northwest of Little Italy in Cleveland's University Circle cultural district. The two-level garden features a large circular marble fountain, a stone parapet, and a bronze bust of the Roman poet Virgil. (Cleveland State University/Cleveland Memory Project.)

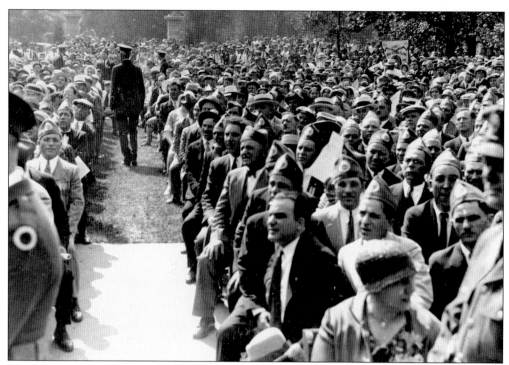

DEDICATION OF THE ITALIAN CULTURAL GARDEN, 1930. The Italian Cultural Garden was formally opened on Columbus Day in 1930, which was also the 2,000th anniversary of Virgil's birth. Over 3,000 members of Cleveland's Italian community were present for the ceremony. Also on hand were city councilman (and Little Italy native) Alessandro DeMaioribus. In his speech, he asked for an embargo on hate, saying that it did not matter whether one's neighbor was Italian, German, French, or English. The garden is currently undergoing a $250,000 project to restore it to its 1930s grandeur. (Above, Cleveland State University/Cleveland Press Collection; below, Cleveland Public Library photograph collection.)

Five

THE PEOPLE

Although the architecture and the institutions of Little Italy have interest, it is the people who created the neighborhood and made it the ethnic stronghold of the early 20th century and the vital arts community it is today. Beginning with Joseph Carabelli in the late 19th century, Italian immigrants went out of their way to share their experiences and success with new arrivals.

Little Italy spawned a variety of interesting persons. Boxers Johnny Farr and Tony Brush grew up in the neighborhood. So did Angelo Vitantonio, the inventor of the hand-cranked home pasta maker. Hector Boiardi (also known as Chef Boy-ar-dee) had a restaurant in Little Italy, and artist Ora Coltman maintained a studio on what is now Coltman Road for over 40 years.

Many sons of Little Italy were drawn to politics, in part to make living conditions better for their Italian brethren. Carabelli was elected to the Ohio House of Representatives, where he helped pass a bill making Columbus Day a state holiday, among other things. Little Italy's 19th Ward has a long history of electing Italian councilmen, among them Alessandro DeMaioribus, Paul DeGrandis, and Anthony Garofoli.

Perhaps the most successful politician to hail from Little Italy was Anthony J. Celebrezze. A World War II veteran, he was elected Cleveland mayor in 1953 and served until 1961. Later he served as a cabinet member in the John F. Kennedy and Lyndon B. Johnson administrations and as a United States appeals court judge.

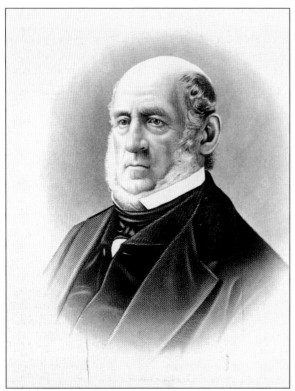

Eugene Grasselli. Eugene Grasselli, although born in Strasbourg of Italian parents, is widely regarded as one of Cleveland's first successful Italian Americans. Grasselli came to Cleveland via Cincinnati in 1856 and opened a chemical plant at the eastern edge of the Cuyahoga Valley, near present-day Newburgh Heights. The company included 14 plants when it was eventually sold to DuPont in 1928. (Cleveland State University/Cleveland Press Collection.)

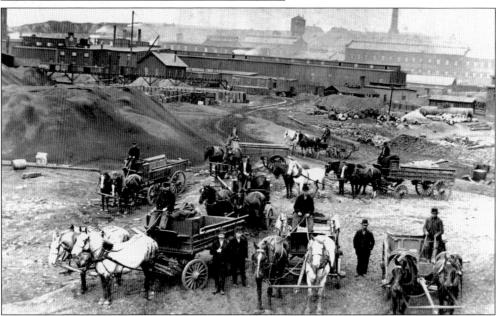

Grasselli Chemical Company. In addition to providing jobs for a generation of new Cleveland immigrants, especially Italians, Poles, and Czechs, members of the Grasselli family were some of Cleveland's earliest philanthropists. Eugene's son Caesar was a founder of the Cleveland Museum of Art and the Cleveland Institute of Music. (Cleveland State University/Cleveland Press Collection.)

FIVE WORKERS AT GRASSELLI HOME. After his death in 1927, Caesar Grasselli donated his family's Euclid Avenue mansion to the Cleveland Society for the Blind (now the Cleveland Sight Center). The center provides job training, counseling, and other services to Cleveland's blind citizens. The organization stayed at that site until 1966. (Cleveland State University/Cleveland Press Collection.)

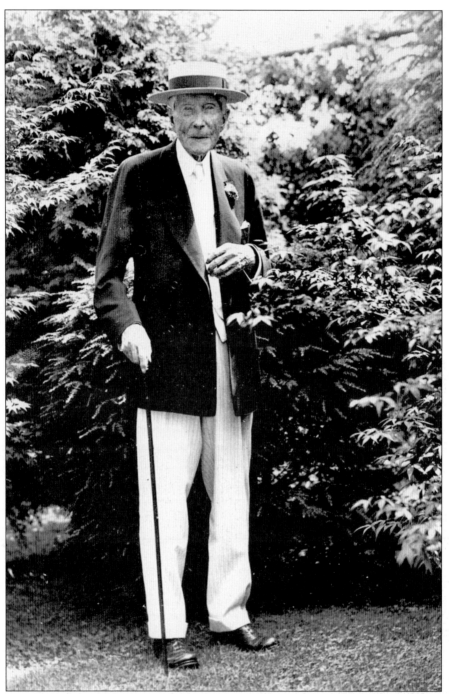

JOHN D. ROCKEFELLER. The founder of the then Cleveland-based Standard Oil Company was a friend to many of Little Italy's early prominent citizens, including Joseph Carabelli and Ora Coltman. It was John D. Rockefeller who financed the original Alta House, which is named for Rockefeller's daughter, Alta Rockefeller Prentice. He later purchased adjacent land for a playground and another building for a library and gymnasium. (Cleveland State University/Cleveland Memory Project.)

BARICELLI INN. Giovanni Alfonso Barricelli was one of the first leaders of Cleveland's Italian community. The cardiopulmonary specialist, born in Italy, opened his practice in Cleveland's Big Italy. He also founded the Cleveland Order of the Sons of Italy. Barricelli built a large stone mansion in Little Italy, at the corner of Murray Hill and Cornell Roads. Today the home is the Baricelli Inn, a stylish restaurant and inn. (Terry M. Goodman.)

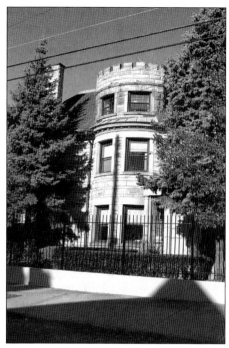

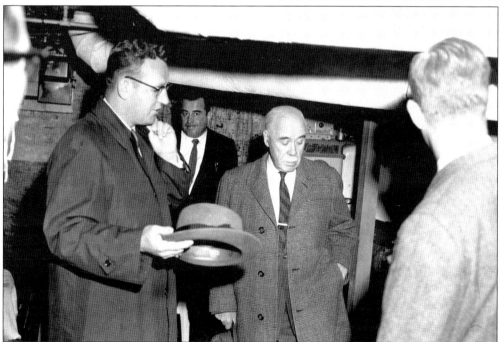

BENJAMIN D. NICOLA. Little Italy's first neighborhood jurist, Benjamin (born Bennedetto) D. Nicola (1879–1970) opened his law office shortly after receiving his law degree from the Ohio State University in 1900. During his long career, he represented many Italian American businesses. In 1948, Nicola was appointed to the Court of Common Pleas, where he served until 1964. He married the former Harriet Stuckey in 1905, and they had four children. (Cleveland State University/Cleveland Press Collection.)

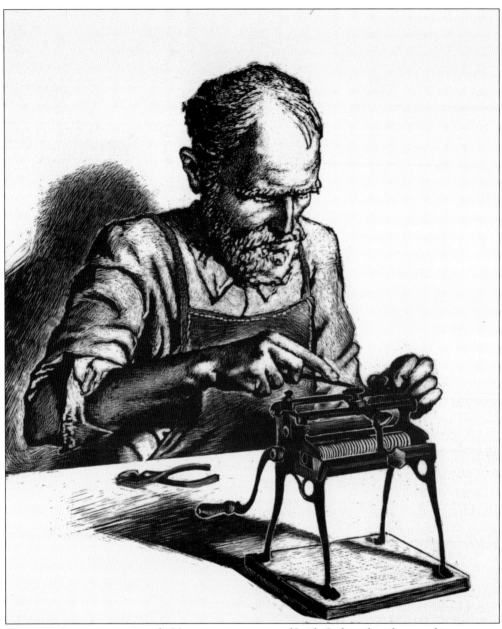

ANGELO VITANTONIO. Angelo Vitantonio, a native of Little Italy, is best known for inventing the hand-cranked pasta machine in 1906, a revolution for the Italian homemaker. The business he created, VillaWare, sells a variety of home kitchen tools and appliances, from espresso makers to cheese graters to the original hand-cranked pasta maker. (Little Italy Heritage Museum.)

LUIGI VITANTONIO. Luigi Vitantonio, Angelo's son, was an accomplished wood-carver. He created the complex designs for pizzelle cookies by first carving them in wood. In addition, he invented the ravioli tray and the cavatelli maker. Luigi's son invented the first Belgian waffle maker for home use. (Little Italy Heritage Museum.)

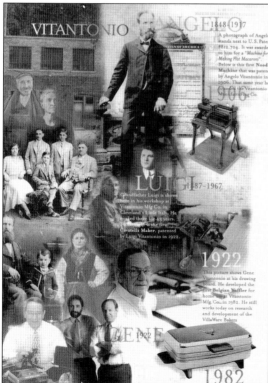

VILLAWARE CATALOG. The Vitantonio family business, VillaWare, still thrives, led by Angelo's great-grandson Bob Vitantonio. From its Little Italy roots, the company has grown to offer dozens of kitchen products. The company is now a subsidiary of the New York–based Jarden Corporation. (Little Italy Heritage Museum.)

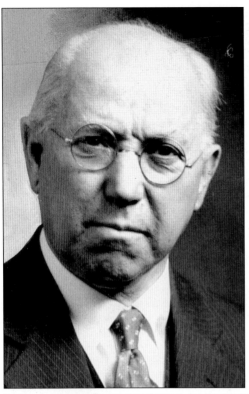

OLINDO G. MELARAGNO. Olindo G. Melaragno was the editor of Ohio's largest Italian-language newspaper, *La Voce del Popolo Italiano*, which thrived in the early 20th century. He was known for his profascist leanings, an attitude not foreign to Little Italy in the 1930s, when residents appreciated seeing their homeland rise to world prominence under Benito Mussolini. (Cleveland State University/Cleveland Press Collection.)

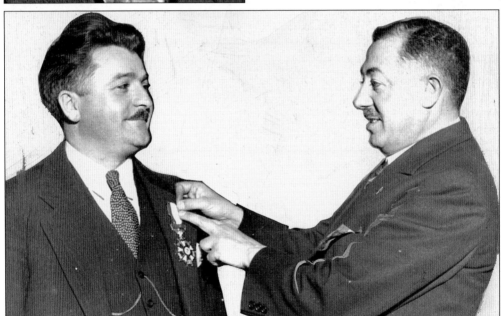

HECTOR BOIARDI. Hector Boiardi (left), better known to the world as Chef Boy-ar-dee, came to Cleveland in 1917 by way of New York City. Boiardi and his wife owned several restaurants, including one in Little Italy called Il Giardino d'Italia. The couple's inexpensive, tasty food was popular during the lean years of the Depression, and the business grew into a wholesale operation in 1928. (Cleveland State University/Cleveland Press Collection.)

ANTONIO AND DOMENICA CICHELLA. Italian immigrants, such as the couple pictured above, created new lives and families in America but generally married fellow immigrants, often those from the same or nearby Italian village. (Little Italy Historical Museum.)

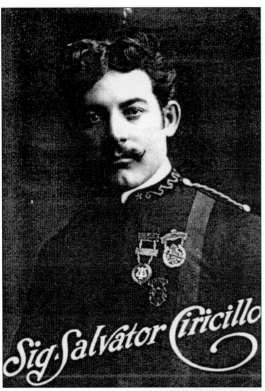

SALVATOR CIRICILLO. Music was a common thread among the residents of the Italian community. All the neighborhood institutions, including Holy Rosary Church, Murray Hill School, and Alta House, sponsored music programs and bands. Alta House even employed Italian bandleader Salvator Ciricillo to teach music. (Little Italy Heritage Museum.)

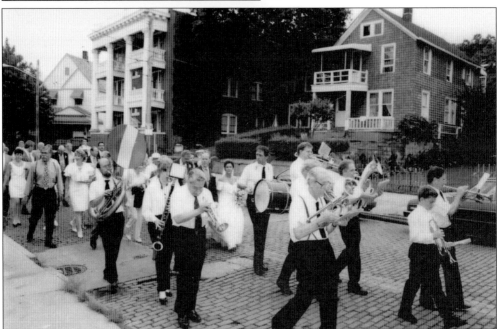

MUSIC IN LITTLE ITALY. Ciricillo's musical tradition continues in Little Italy, with bands still an integral part of any celebration, including this 1970s wedding parade. The Alta House Italian Band continues to perform in the neighborhood and is a favorite during the Feast of the Assumption. (Little Italy Heritage Museum.)

JOSEPH CERUTI. Joseph Ceruti was a renowned Cleveland architect—and a Little Italy native. A graduate of Western Reserve University (now Case Western Reserve University), he designed the Holy Rosary school building as well as the 12-story Shaker Towers apartment building at Shaker Boulevard and Coventry Road and the 1949 restoration of Cleveland's West Side Market. Ceruti died in 1993 and is buried at Lake View Cemetery. (Cleveland State University/Cleveland Press Collection.)

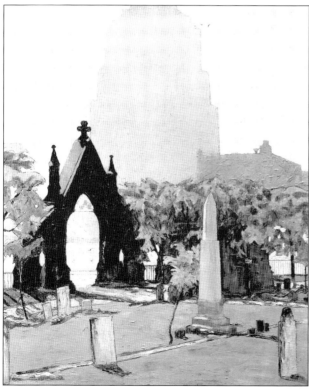

MONUMENTS, A PAINTING BY ORA COLTMAN. Ora Coltman (1858–1940) hailed from Shelby, in north-central Ohio, but maintained a studio in Little Italy for most of his adult life. He was a painter, sculptor, block printer, muralist, and teacher and his work hangs in Youngstown's Butler Institute of Art, among other galleries. Coltman Road, which runs alongside Holy Rosary Church, is named for him. At left is his painting *Monuments*, which depicts Cleveland's Erie Street Cemetery. (Cleveland State University/Cleveland Press Collection.)

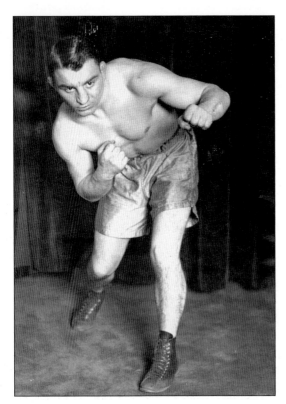

JOHNNY FARR. Johnny Farr (born John Farinacci) competed as a flyweight in fights at Cleveland's Public Hall and other venues throughout the United States during the 1920s and 1930s. The five-foot fighter won 44 of the 115 bouts in which he participated. (Cleveland State University/Cleveland Press Collection.)

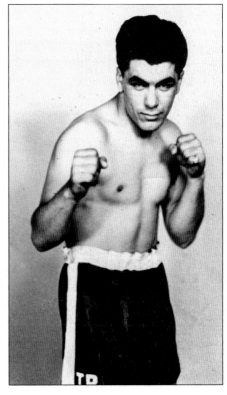

TONY BRUSH, 1940. Another boxer from Little Italy, Anthony Brescia was known in the boxing world as Tony Brush. Brush was an amateur boxer and the 1943 Golden Gloves champion. He is immortalized today with the Little Italy park at Random and Mayfield Roads that bears his name. (Cleveland State University/Cleveland Press Collection.)

COUNT CAESAR GRADENIGO. The Italian government maintained a consulate in Cleveland from the early 1900s until 1978. Between the wars, from 1930 to 1936, that office was headed by Count Caesar Pierre Albert Buzzi Gradenigo. A dapper and elegant man, Gradenigo was popular in the Italian community despite his fascist leanings. The Italian consul was also very vocal on the cause of Italian pride and self-awareness and admonished Cleveland's Italian American community not to forget the customs and language of its home country. (Cleveland State University/Cleveland Press Collection.)

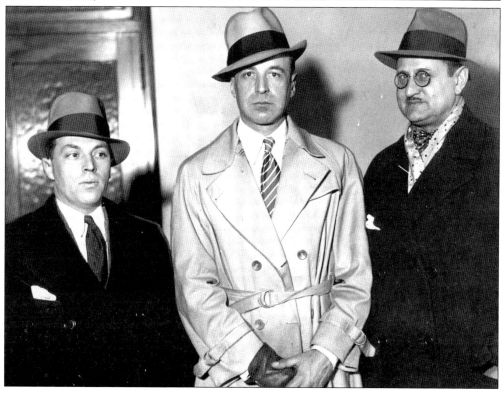

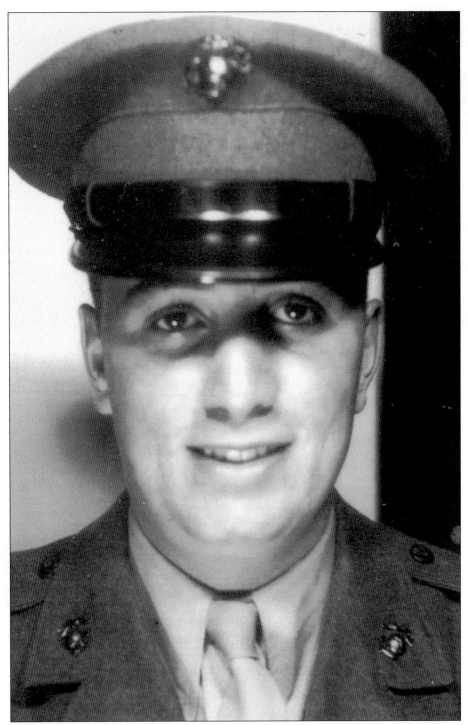

FRANK J. DIROSA. After the Japanese attack at Pearl Harbor on December 7, 1941, thousands of Clevelanders, including the residents of Little Italy, flocked to area recruiting offices. One such soldier was Little Italy resident Frank J. DiRosa (above). During the over four years of combat, more than 4,000 Clevelanders perished. (Little Italy Historical Museum.)

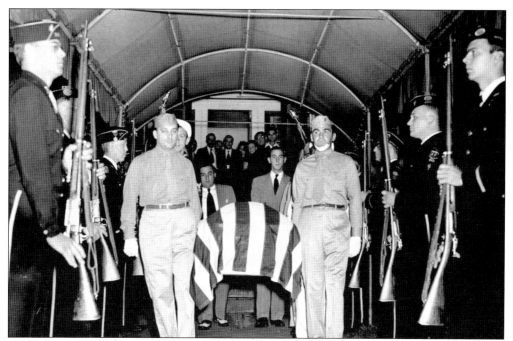

FRANK PETRARCA FUNERAL, 1944. Not all the hundreds of Italian Americans from the Cleveland area who fought in World War II made it back home. One such soldier, Frank Petrarca, was awarded the Congressional Medal of Honor for his bravery in aiding three wounded soldiers during combat on the Solomon Islands. He was killed on his 25th birthday in 1943, during a similar operation. His body was returned to Cleveland where he was buried at Calvary Cemetery, on the city's east side. (Cleveland State University/Cleveland Press Collection.)

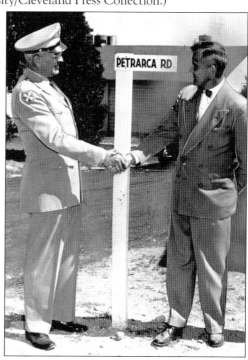

FRANK PETRARCA ROAD, 1954. Several northeast Ohio sites are named for Little Italy war hero Frank Petrarca, including a road in Cleveland, just off Fairhill Road on the city's east side; an Ohio National Guard armory in Brookpark; and an American Legion post in Cleveland. (Cleveland State University/ Cleveland Press Collection.)

FRANCES BOLTON, 1968. Although not Italian, Frances Bolton was a great friend and supporter of Cleveland's ethnic communities, including Little Italy. When her husband, Chester Bolton, died in 1939, she assumed his seat in the United States House of Representatives, earning the seat in her own right in 1940. She served in Washington for 29 years but never forgot the people of Cleveland, supporting projects in nursing, health, and education. (Cleveland State University/Cleveland Press Collection.)

ALESSANDRO LOUIS "SONNY" DEMAIORIBUS. Alessandro Louis "Sonny" DeMaioribus (1898–1968) was raised in Little Italy, just around the corner from Holy Rosary Church, and graduated from Murray Hill School. He was one of the first Italians to be elected to public office in Cleveland, when he won a seat on city council in 1927. He served there for 20 years, 8 of them as president. (Little Italy Heritage Museum.)

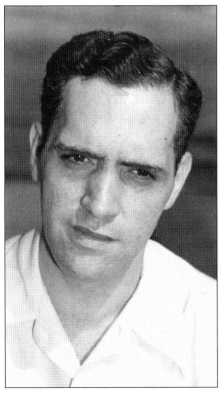

PAUL DEGRANDIS. Paul DeGrandis (1929–1993) was one of several Little Italy politicians who helped develop the area and keep active the interests of the Italian community. DeGrandis represented the 19th Ward on Cleveland City Council from 1958 to 1969. He also presided over Local 100 of the American Federation of State, County, and Municipal Workers; served on the board of the Cleveland Public Library; and was deputy director of the Cuyahoga County Board of Elections. (Cleveland State University/Cleveland Press Collection.)

ANTHONY GAROFOLI. Anthony Garofoli (1936–2003) was another of Cleveland's Italian political powerhouses. The lawyer was elected to represent Cleveland's 19th Ward in city council in 1965 and served as its council president from 1970 to 1972. Garofoli was also cochairman of the Cuyahoga County Democratic Party for most of the 1970s. After retiring from public office, he became a partner with the Cleveland law firm of Climaco, Lefkowitz, Peca, Wilcox and Garofoli. Below he is pictured with his family. (Cleveland State University/Cleveland Press Collection.)

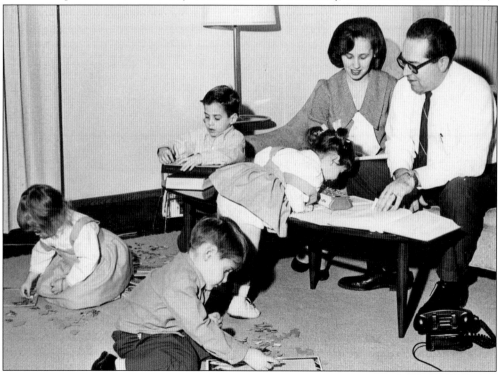

George Costello. Following the lead of Alessandro DeMaioribus in 1927, Little Italy continued to elect an Italian to city council. DeMaioribus was succeeded in 1947 by George Costello (at right). He was followed by Paul DeGrandis in 1957 and Anthony Garofoli in 1965. (Cleveland State University/Cleveland Press Collection.)

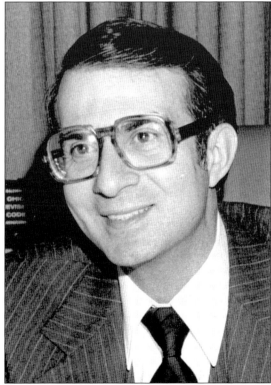

Vincent Campanella. Another notable Italian American politician, Vincent Campanella served as law director under Mayor Ralph Perk during the mid-1970s. (Cleveland State University/Cleveland Press Collection.)

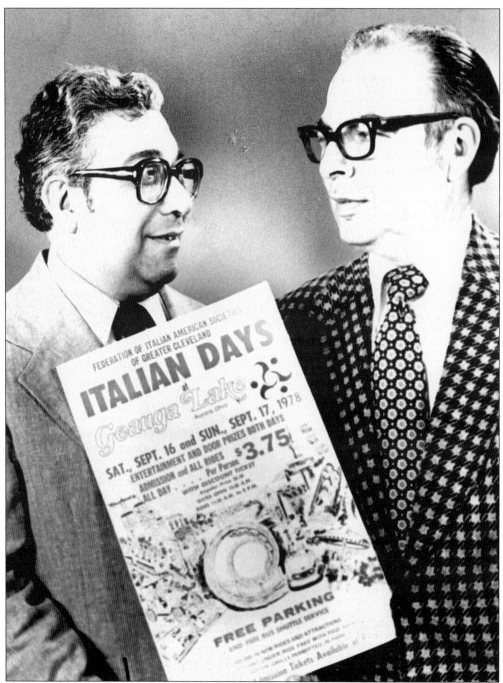

SAM DIMAURO. Cleveland businessman and Little Italy native Sam DiMauro (left) was a big supporter of Cleveland's Italian Days, a summer festival that began in 1968 and was supported by the over 40 Italian clubs in northeast Ohio. The tradition continued through the 1980s. (Cleveland State University/Cleveland Press Collection.)

FRANK D. CELEBREZZE. Born to Italian immigrants, Frank D. Celebrezze (1899–1953) was one of the first sons of Little Italy to rise through the ranks of Cleveland politics. Celebrezze, a Notre Dame Law School graduate, was appointed assistant Cuyahoga County prosecutor in 1929. He also served as Cleveland parks director and replaced Eliot Ness as Cleveland safety director in 1942. He was later twice elected judge of the municipal court. (Cleveland State University/Cleveland Press Collection.)

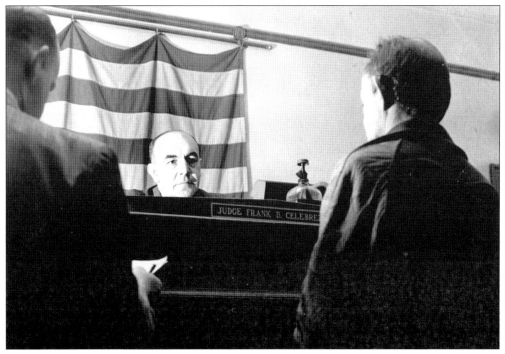

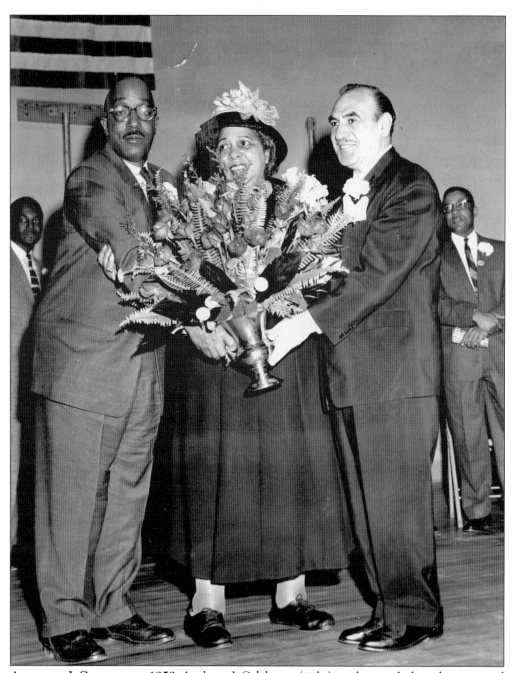

ANTHONY J. CELEBREZZE, 1959. Anthony J. Celebrezze (right) was born in Italy and immigrated to Cleveland with his family as a young boy. He served in the U.S. Navy during World War II, earned a law degree, and was elected mayor of Cleveland in 1953. Celebrezze later served as health, education, and welfare secretary for both the John F. Kennedy and Lyndon B. Johnson administrations and served as a federal appellate judge until his death in 1998. (Cleveland State University/Cleveland Memory Project.)

THOMAS PARRINO. An assistant Cuyahoga County prosecutor and later an appellate judge, Thomas Parrino (right) is best known for his involvement in the first Sam Sheppard murder trial in 1954, where the Bay Village doctor was accused of murdering his pregnant wife. Parrino was part of the five-member prosecution team. (Cleveland State University/Cleveland Press Collection.)

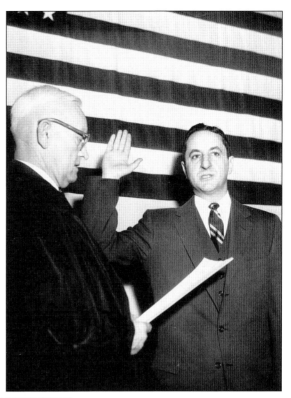

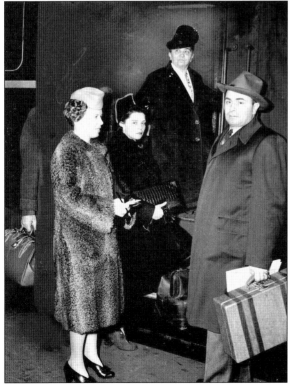

S. M. LoPRESTI, 1944. A. LoPresti and Sons was one of the small Italian-owned grocery businesses in Cleveland that blossomed into a large food distributor. S. M. LoPresti (right) was just one of many family members who helped to create a company that today has a fleet of 30 trucks and delivers to over 1,000 customers. (Cleveland State University/Cleveland Press Collection.)

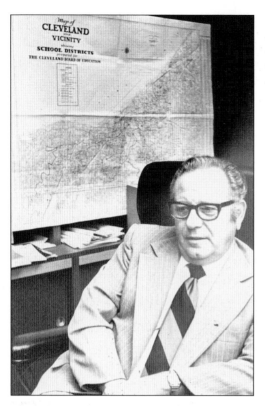

FRANK JOSEPH BATTISTI. Italian American Frank Joseph Battisti presided over one of the most controversial and most far-reaching Cleveland court cases of the 20th century. On August 31, 1976, federal judge Battisti ruled in *Reed v. Rhodes*, the Cleveland public school desegregation case, that the Cleveland schools had practiced racial segregation. He cited Little Italy's Murray Hill School as an example of institutionalized segregation. (Cleveland State University/Cleveland Press Collection.)

LOUIS DEPAOLO, 1964. Louis DePaolo, a native of Campobasso, was a business owner, Italian radio announcer, travel agent, and unofficial mayor of Little Italy for much of the 20th century. DePaolo also published the popular Italian newspaper *L'Araldo* from 1952 to 1959. Residents of the neighborhood knew that they could always find friendly advice in DePaolo's Mayfield Road store. (Cleveland State University/Cleveland Press Collection.)

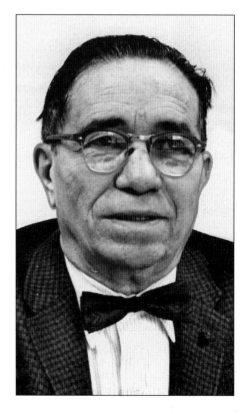

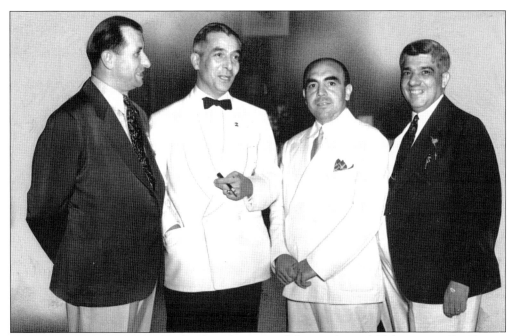

Dr. Romeo Montecchi. Cleveland's Italian consul during the mid-20th century, Dr. Romeo Montecchi (second from left) socializes with other prominent Cleveland Italian Americans, including (from left to right) Herman Carlotti, Frank D. Celebrezze, and Natale Comella. (Cleveland State University/Cleveland Press Collection.)

Donald Traci, 1965. As second and third generations of Italian American Clevelanders came of age, they took their places in government, law, and medicine, among other professions. One of these successful sons of the old neighborhood was trial lawyer Donald Traci (far left). (Cleveland State University/Cleveland Press Collection.)

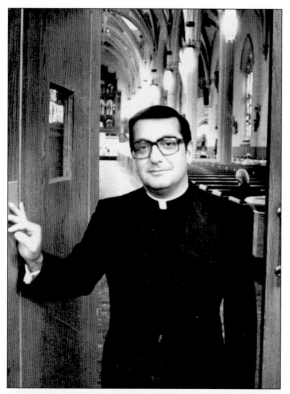

BISHOP ANTHONY PILLA AND LIBERA PILLA. The Most Reverend Anthony Michael Pilla was a son of the Little Italy neighborhood, one of two boys born to Italian immigrants Libera and George Pilla. Bishop Pilla was ordained as a priest in 1959 and elevated to bishop of the Diocese of Cleveland in 1981, in a ceremony held at his boyhood parish, Holy Rosary Church. He was the first Clevelander to serve in that post. Bishop Pilla retired as bishop in 2006. Libera Pilla (below), who passed away in 2004, has been quoted several times as saying that seeing her son ordained as bishop of Cleveland was one of the proudest moments of her life. (Cleveland State University/Cleveland Press Collection.)

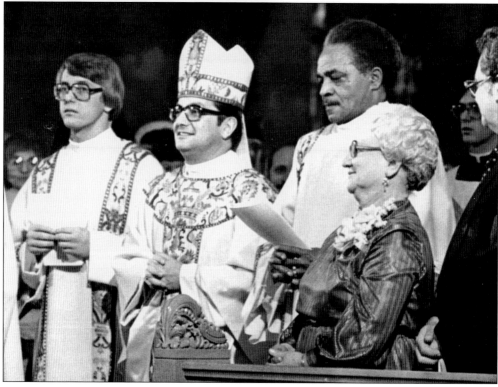

Six
THE FOOD AND THE RESTAURANTS

Food is an essential part of any Italian community, and Cleveland's Little Italy is no exception. As soon as Italians started arriving in the neighborhood, restaurants, bars, and bakeries started springing up along Mayfield Road and the nearby side streets. Some of these establishments, such as Guarino's, are still in business today.

The variety of restaurants and food stores has mirrored the tastes and enthusiasms of the Little Italy community throughout its history. Restaurants vary from modest to fine dining, and the fare ranges from northern Italian elegance to hearty Sicilian red sauce and pasta. Consistent throughout is the well-trained waitstaff, a generous selection of affordable wine, and that friendly Little Italy welcome. These establishments continue to be the neighborhood meeting places and social centers as well as being sources of sustenance.

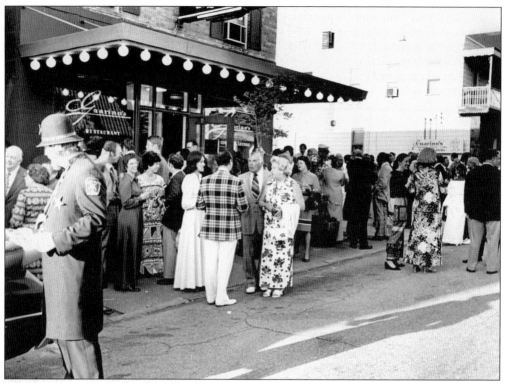

Guarino's, 1975 and 2007. Guarino's Restaurant, on Mayfield Road, opened in 1918 and is Cleveland's oldest Italian restaurant. The eatery has weathered the Depression, Prohibition, and the exodus of many of the neighborhood's Italian residents to Cleveland's eastern suburbs. The restaurant serves traditional Italian fare—pasta, veal, chicken—and has made few variations on the original menu. Today Guarino's is just one of a dozen or so popular restaurants in the Little Italy neighborhood. The eatery's rich red brocade walls and dark woodwork have changed little throughout the years and lend the dining room an enchanting Italian charm. (Above, Cleveland State University/Cleveland Press Collection; left, Terry M. Goodman.)

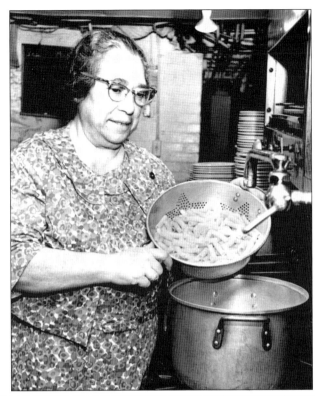

MARY GUARINO, 1967. Mary Guarino, of Guarino's Restaurant, was just one of dozens of hardworking first-generation Italians who contributed to Little Italy's sense of taste and community. She was indicative of the Italian ethic of hard work and self-sufficiency. (Little Italy Heritage Museum.)

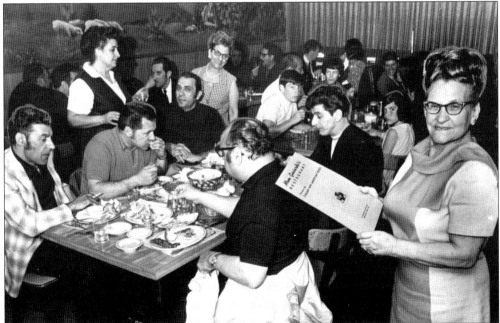

MOM GUCIARDO'S RESTAURANT. Members of Cleveland's Italian American community opened Italian eateries all over town, like Mom Guciardo's at University Circle. In fact, the city has more Italian restaurants than any other ethnic-style restaurant. (Cleveland State University/Cleveland Press Collection.)

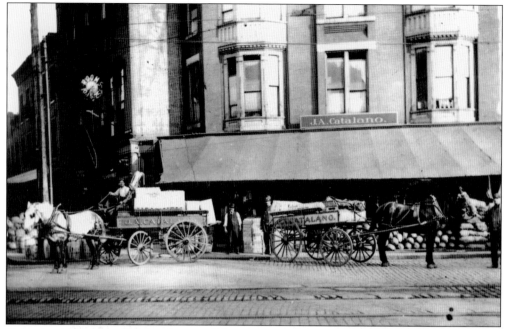

CATALANO MARKET. Catalano's, one of the many small groceries begun by Italian Americans in Cleveland, started on Woodland Avenue in the city's Big Italy neighborhood before moving east. Descendants of the early Catalano family are still grocers in Greater Cleveland today. (Little Italy Heritage Museum.)

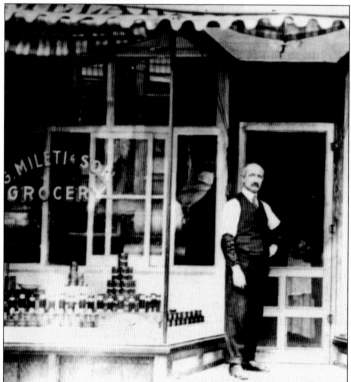

GAETANO MILETI, 1910. One of the first merchants in Little Italy, G. Mileti and Son Grocery, located at the corner of Murray Hill and Mayfield Roads, was indicative of the entrepreneurial spirit among the Italian American community. (Little Italy Heritage Museum.)

FRANKIE AND JOHNNIE'S, 1968. Little Italy has always been home to a collection of popular, mostly southern Italian–style, restaurants. During the 1960s, Frankie and Johnnie's was a popular place to eat. (Cleveland State University/Cleveland Press Collection.)

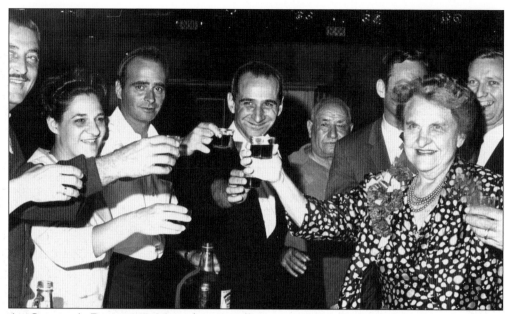

AT GALUCCI'S BAR, 1967. More than just places to eat and drink, Little Italy's eateries and bars were places to meet friends, celebrate political victories (as does Congresswoman Frances Bolton, above in the dotted dress), and keep up on the latest neighborhood events. (Cleveland State University/Cleveland Press Collection.)

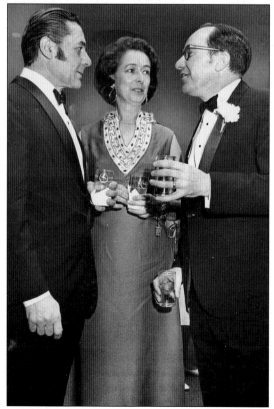

MARIO ANZIANO, 1974. Little Italy has never had a shortage of watering holes. The area claimed over two dozen bars in the era after the repeal of Prohibition, and that tradition has continued into the 21st century. At left are Italian consul Mario Anziano (left) and his wife enjoying an evening with friends in the neighborhood. (Cleveland State University/Cleveland Press Collection.)

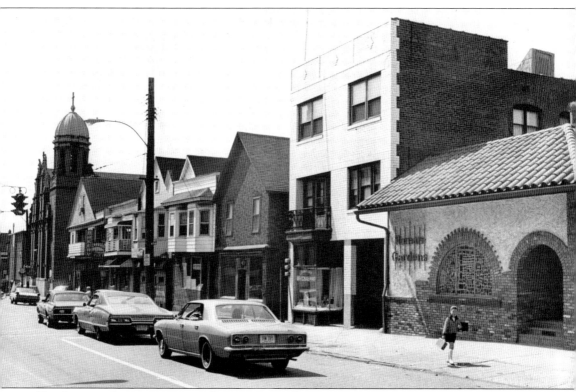

THE ROMAN GARDENS, 1968. The Roman Gardens, now Trattoria on the Hill, has been one of the most popular restaurants in Little Italy for generations. Located on Mayfield Road in the heart of the neighborhood, the traditional eatery evokes the spirit of southern Italy with its signature red sauce, checkered tablecloths, and lively atmosphere. (Cleveland State University/Cleveland Press Collection.)

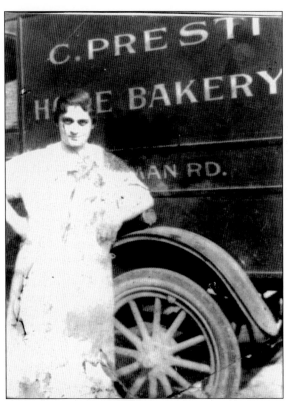

ROSA PRESTI AND PRESTI'S. Charles and Rosa Presti started their bakery business on Coltman Road in 1920 and moved the business to Mayfield Road in 1938. The place continues to be a popular spot for meeting friends and enjoying a cup of coffee. In addition to a variety of breads and baked goods, Presti's now offers desserts and sandwiches and a spacious dining area. (Left, Little Italy Heritage Museum; below, author's collection.)

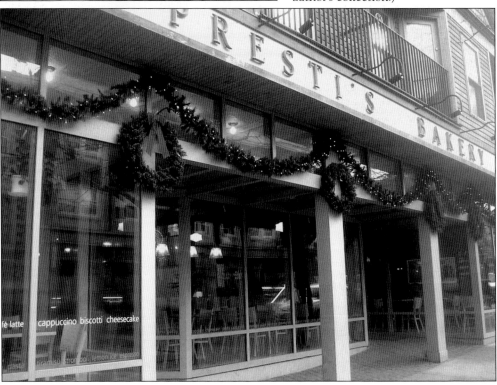

THE GOLDEN BOWL. The Golden Bowl Restaurant, located along Mayfield Road in the heart of Little Italy, was a favorite of generations of Clevelanders, Italian and not, before it closed its doors for the last time in 2005. The restaurant was noted for its romantic patio, plush inside decor, and traditional Sicilian favorites. (Cleveland State University/Cleveland Press Collection.)

PAUL MINILLO, 1964. Paul Minillo (second from left in the rear) owned several popular Little Italy restaurants, including Minillo's and Minillo's Greenhouse, located at the western edge of Murray Hill Road. His son Paul Jr. currently is the owner and head chef at the neighborhood's elegant Baricelli Inn restaurant. (Cleveland State University/Cleveland Press Collection.)

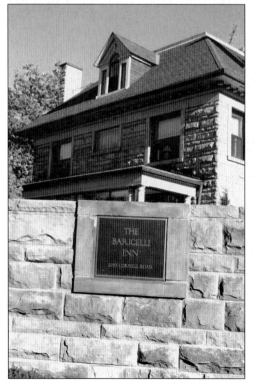

THE BARICELLI INN. Dr. Giovanni Alfonso Baricelli was a prominent Italian American physician in the early 20th century who specialized in pulmonary and cardiac medicine and occasionally lectured at nearby Western Reserve University. His large stone home, at the corner of Murray Hill and Cornell Roads, is now an elegant restaurant and bed-and-breakfast inn. (Terry M. Goodman.)

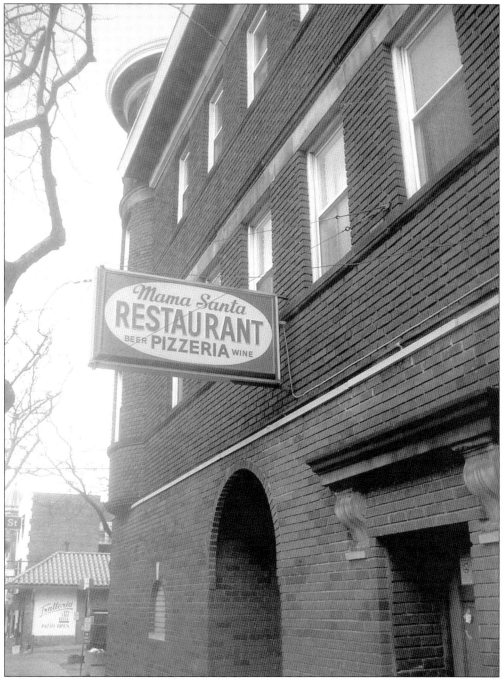

MAMA SANTA'S. Mama Santa's is, arguably, the best place in Cleveland for pizza. The family-owned pizzeria, a Little Italy fixture since the 1940s, serves thin crust pizzas and a variety of other Italian favorites. The decor and friendly ambiance are guaranteed to take one back a few decades. (Author's collection.)

CORBO'S DOLCERIA. Located at the corner of Mayfield and Murray Hill Roads, Corbo's has been serving up sweets for over four generations. The family-owned business is a favorite stop for locals and visitors alike. In fact, "Iron Chef" Mario Batali told *USA Today* in 2007 that Corbo's had the best cassata cake in the United States. Corbo's is also known for its delicious tiramisu, assorted butter cookies, and pizza bread. During the holiday season, the place is filled to the rafters with Italian confections of every kind. At left are the owners in 1970. (Above, Terry M. Goodman; left, Little Italy Heritage Museum.)

Seven
LITTLE ITALY TODAY

Little Italy at the beginning of the 21st century is decidedly different from the self-contained Italian enclave that housed thousands of new residents in the early 20th century. Then one rarely ventured south of Euclid Avenue or north into the "heights" of Cleveland, and the only reason to travel to downtown was for work. Now visitors from all over northeast Ohio seek out Little Italy's art galleries and restaurants. Hundreds of thousands of revelers join residents each August for the Feast of the Assumption, and the thrice-annual Murray Hill Art Walks are a much-anticipated Cleveland activity.

Yet some things remain the same. Holy Rosary Church continues to be the backbone of the community, much as it was 100 years ago. Alta House has changed buildings and many of its programs, but its mission remains the same—to assist the neighborhood residents, both young and old.

Those who have never visited Little Italy should reserve an afternoon for a walk through its colorful streets. Visitors will find interesting architecture, delicious food, colorful pocket gardens, and a warm welcome from the people who call this historic neighborhood home.

LITTLE ITALY HISTORIC DISTRICT. Today Little Italy is a historic district, one of 23 such designated areas in Cleveland. Much as it did when it was first settled in the late 1880s, the compact neighborhood retains its Italian Old World flair, with brick streets, a plethora of Italian restaurants and food stores, and the highlight of the year, the Feast of the Assumption, held each August 15. (Terry M. Goodman.)

LITTLE ITALY STREET SIGN. Little Italy remains a distinct neighborhood, bounded by University Hospitals of Cleveland to the north, Lake View Cemetery on the east, and Case Western Reserve University on the west. The neighborhood's two main arteries are Mayfield and Murray Hill Roads. Currently Little Italy has a permanent population of around 4,000 residents plus a number of students from the university. (Terry M. Goodman.)

MURRAY HILL SCHOOL. Built in 1907, Murray Hill School was once filled with over 1,000 elementary school children. The brick school building closed in 1978, when migration to the suburbs left only a handful of students. The three-story school has been reborn as an artists' refuge. Former classrooms are now artist studios and galleries. Perhaps the most unique of these is housed in the school's former boiler room. (Terry M. Goodman.)

GALLERIES IN MURRAY HILL SCHOOL. The galleries inside Murray Hill School are an eclectic combination of art mediums and art forms. Tenants include a textile art store, a high-end glass gallery, several painters' studios and galleries, and Juma Gallery, an emporium of handmade wooden objects, clothing, paintings, and sculpture. (Author's collection.)

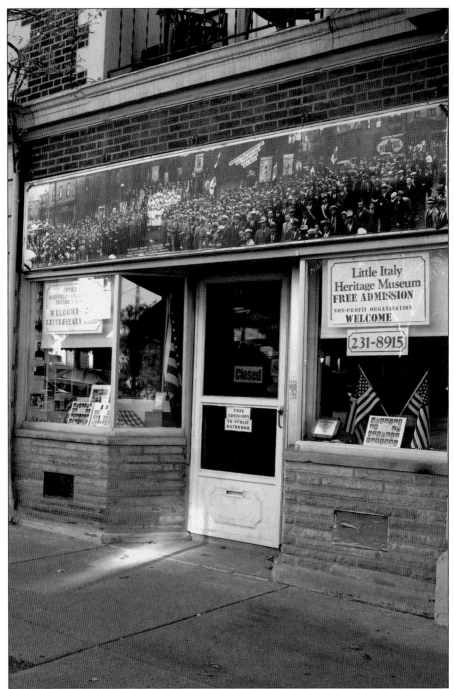

LITTLE ITALY HERITAGE MUSEUM. The Little Italy Heritage Museum, on Mayfield Road, housed a quirky yet informative collection of photographs, illustrating the history of the neighborhood from the late 19th century to the present, for over a decade until it closed at the end of 2007. The photographs as well as the artifacts, including an Old World winepress and a festively painted handcart, have been donated to the Western Reserve Historical Society, in the nearby University Circle cultural district. (Terry M. Goodman.)

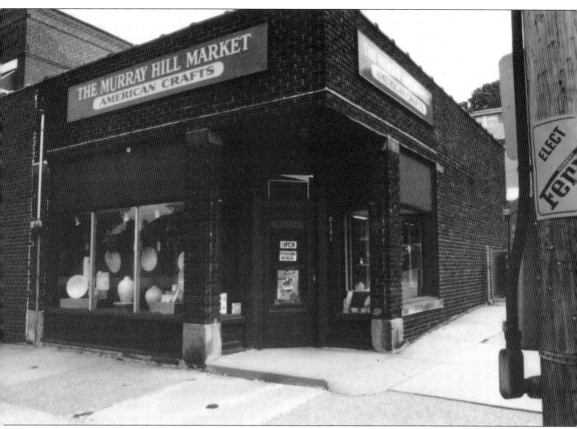

Murray Hill Arts and Crafts. The Murray Hill Market, at Murray Hill and Cornell Roads, was one of the first art galleries to establish itself in Little Italy. The eclectic store features an assortment of handmade items and antiques, including glass art, jewelry, furniture, and a dazzling array of holiday ornaments. (Little Italy Heritage Museum.)

VILLA CARABELLI TOWNHOUSES. Just one of several new residential projects in Little Italy, the Villa Carabelli Townhouses is a cluster of 20 luxury four-level homes that combine modern conveniences with the look and feel of the old neighborhood. Located along Mayfield Road across from Lake View Cemetery, the town houses feature rooftop patios with views of University Circle and the city beyond. (Terry M. Goodman.)

MURRAY HILL ART WALK. Each year, Little Italy hosts three art walks, in June, October, and December. The 30 galleries in the neighborhood, as well as a handful of artist studios, open their doors to shoppers and sightseers. Available art includes paintings, ceramics, carved pieces, and glass, among other things. (Terry M. Goodman.)

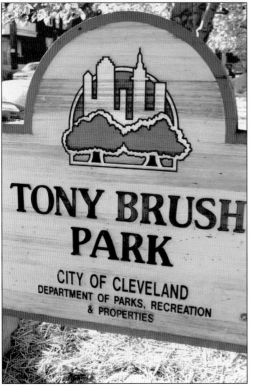

TONY BRUSH PARK. Tony Brush Park, located at the intersection of Random and Mayfield Roads, is one of the newer additions to Little Italy. This green space development was completed in May 2007 and features a playground, a baseball diamond, ample benches, and a basketball court. The park is named for champion boxer and Little Italy resident Anthony Brescia (also known as Tony Brush). The park is just one of the many improvements spearheaded by the Little Italy Redevelopment Corporation in recent years. (Terry M. Goodman.)

BIBLIOGRAPHY

Miller, Carol Poh, and Robert A. Wheeler. *Cleveland: A Concise History, 1796–1996.* 2nd ed. Bloomington, IN: Indiana University Press, 1997.
Pap, Michael S., Ph.D. *Ethnic Communities of Cleveland.* Cleveland: John Carroll University, 1973.
Peoples of Cleveland, The. Compiled by the WPA Writers Program Workers, 1942.
Ricordi della Piccola Italia. Cleveland: Little Italy Historical Museum, 1996.
Van Tassel, David D., and John J. Grabowski. *Encyclopedia of Cleveland History.* Bloomington, IN: Indiana University, 1987.
Veronesi, Gene P. *Italian Americans and Their Communities of Cleveland.* Cleveland: Cleveland State University, 1977.

Across America, People are Discovering Something Wonderful. Their Heritage.

Arcadia Publishing is the leading local history publisher in the United States. With more than 3,000 titles in print and hundreds of new titles released every year, Arcadia has extensive specialized experience chronicling the history of communities and celebrating America's hidden stories, bringing to life the people, places, and events from the past. To discover the history of other communities across the nation, please visit:

www.arcadiapublishing.com

Customized search tools allow you to find regional history books about the town where you grew up, the cities where your friends and family live, the town where your parents met, or even that retirement spot you've been dreaming about.